2 27/5/97

2 80

D1341939

2 27/5/97

2 80

# Alwyn and June Crawshaw's
## OUTDOOR
# PAINTING COURSE

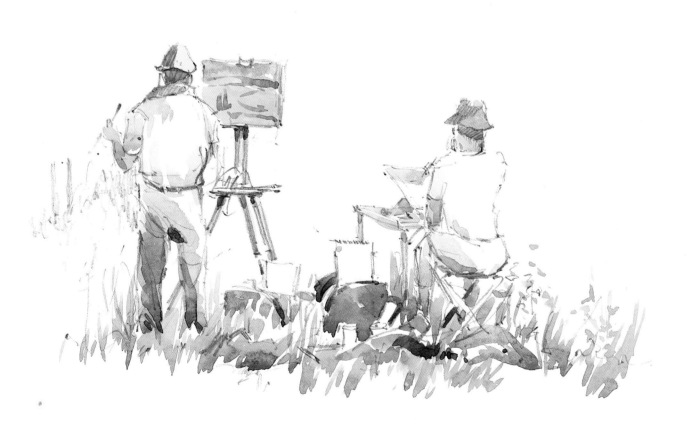

# Alwyn and June Crawshaw's
## OUTDOOR
# PAINTING COURSE

*Alwyn and June*
*Crawshaw*

HarperCollins*Publishers*

## ACKNOWLEDGEMENTS

June and I would like to record our sincere thanks to
Cathy Gosling from HarperCollins, to Flicka Lister for designing and
editing this book, and also to Mary Poole for typing the manuscript.
We would also like to thank Pat and Graeme Bree, who painted
along with us on our Brittany trip, and all the kind and helpful
people we met during our painting sessions for this book.

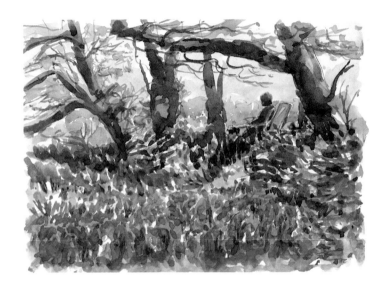

First published in 1997
by HarperCollins*Publishers*, London

© Alwyn Crawshaw, 1997

Alwyn Crawshaw asserts the moral right to be identified
as the author of this work.

All rights reserved. No part of this publication may be
reproduced, stored in a retrieval system, or transmitted,
in any form or by any means, electronic, mechanical,
photocopying, recording or otherwise, without
the prior written permission of the publishers.

Designed, edited and typeset by Flicka Lister
Photography by June and Alwyn Crawshaw
and Nigel Cheffers-Heard

**A catalogue record for this book is available
from the British Library**

ISBN 0 00 412760 9

Colour origination by Colourscan, Singapore
Produced by HarperCollins Hong Kong

# CONTENTS

# INTRODUCTION

▲ *June and Alwyn Crawshaw.*

Whenever June and I are preparing to go on a painting trip, I am filled with a wonderful feeling of anticipation as I check and recheck my painting equipment, making sure I have everything I need. Discovering new ways of packing important items, or remembering useful additions at the very last minute, only adds to my excitement, as does the thought of where we are going and what we are going to paint there. It can be such a thrill painting in unfamiliar surroundings, especially in a foreign country. Incidentally, I always find that, even if you don't speak the language, a smile and a phrasebook will see you through!

## LASTING MEMENTOS

Outdoor painting brings a special dimension to the artist, whether your trip is a two-week holiday or an afternoon spent discovering local painting spots. Whether you paint a masterpiece or just do quick pencil or watercolour sketches, you will have experienced the joy of observing and recording your surroundings and the satisfaction of taking a lasting memento home with you.

When June and I are out painting, we often say that it's a pity we don't have students with us who could learn by watching us work and share in our fun and problem-solving at first hand. This made us think about writing a book on the subject and so the idea for *Alwyn & June Crawshaw's Outdoor Painting Course* was born.

◀ *A photograph of my first stage drawing of Hound Tor.*

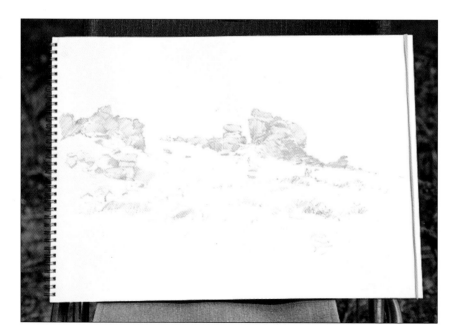

6

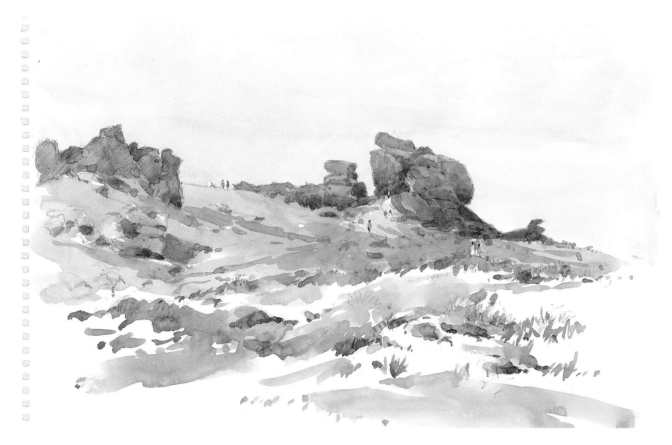

▲ HOUND TOR, DARTMOOR
Watercolour on cartridge paper
23 × 33 cm (9 × 13 in)

*It was only when I had finished this painting during our experimental working that I remembered I was meant to photograph some more stages. We also had to write notes about each stage, so a trip out painting did get a little complicated!*

We decided that, to reflect the different working conditions an artist can encounter, the book should show as many paintings being created outdoors as possible. In most art instruction books, painting stages are taken by a professional photographer under constant lighting conditions in the artist's studio. This ensures the best quality reproduction and consistency of colours but means that paintings have to be done indoors from sketches and photographs rather than out-of-doors. June and I decided to experiment with a more realistic approach and, next time we went on our travels, we packed our camera as well as our painting gear.

## PAINTING EXPERIMENTS

We spent many hours painting in different weather conditions, taking stage photographs as we worked. This experimental time was well-spent and we found that a large percentage of our photographs were usable. Our biggest problem was changing light but another factor we hadn't even considered was how involved in a painting one can become. For example, having photographed my first stage drawing (left), I became so totally absorbed in my painting of Hound Tor (above) that I forgot to take any more photographs! However, the first stage is helpful as it shows how much drawing I did before I painted the scene.

I also did a lot of pencil shading before I worked with my watercolours and you couldn't have seen this if I hadn't taken a photograph of the first stage. Incidentally, scale is very important in this painting – it would be impossible to relate to the size of rocks without some figures in the picture.

Eventually, June and I showed the results of our photographic and artistic endeavours to our publishers and were delighted to be given the go-ahead to do the book. Naturally, our stage photographs won't be as good as ones taken in the studio by a professional photographer but I am sure that having this unique chance to see the way we work when we are painting outdoors will more than compensate the reader for any quality lost. Where possible, we have included a photograph that we took of the scene for each demonstration so that you can see how June or I interpreted it in our painting. Our stage demonstrations are also interspersed with many other sketches and paintings that we have done outdoors over the last couple of years.

## MEMORABLE PAINTING MOMENTS

When June and I look through the paintings we have done for the book, memories come flooding back. June will never forget the painting she did while perched precariously on the edge of the cliff overlooking Janvrin's Tomb at Portelet in Jersey (shown below). In a very short time the wind had whipped up to gale-force and was constantly buffeting her as she worked, which made painting (and balancing) extremely difficult. I was sitting beside her, trying to do an oil painting but found the wind too strong and made a mess of my picture! However, June's turned out very well. Notice the small figures on the beach at the bottom of the picture. These are very important to the painting as, once again, they illustrate the scale.

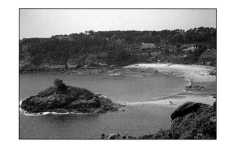

▼ JANVRIN'S TOMB, PORTELET, JERSEY
Watercolour on Bockingford 200 lb paper
28 × 38 cm (11 × 15 in)

*Just as with my painting of Hound Tor on the previous page, scale was very important in June's picture.*

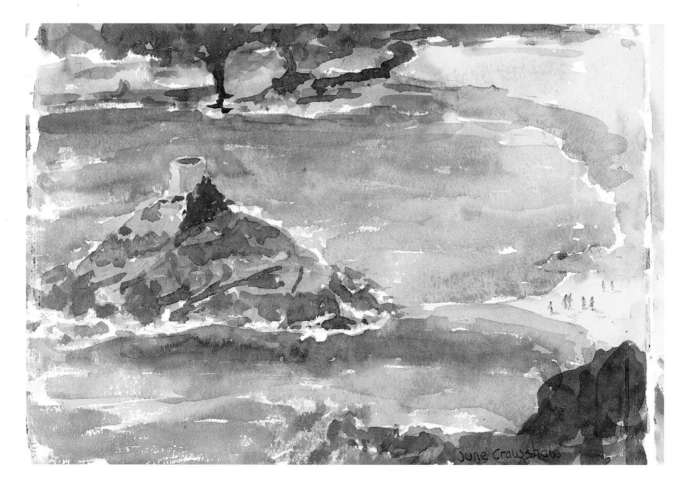

June Crawshaw

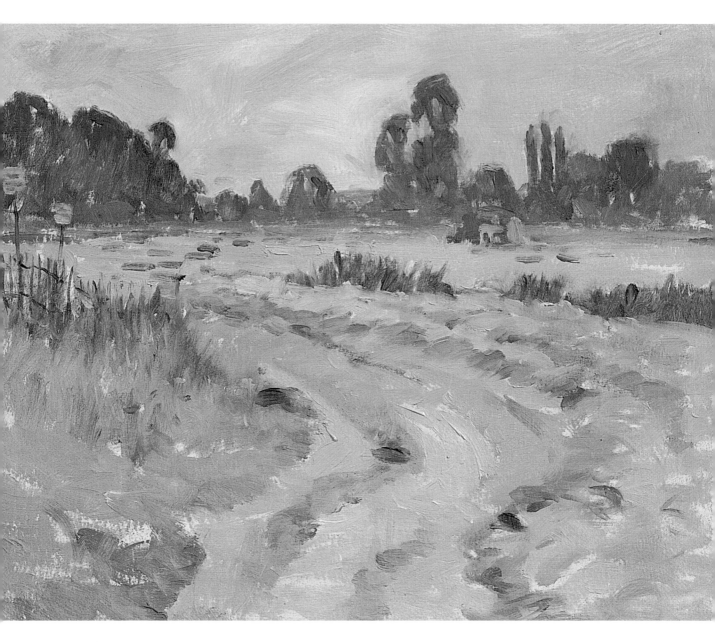

Painting outside can involve a certain amount of discomfort but it is almost always worthwhile. Another picture that immediately springs to my mind is the oil painting I did at Tewkesbury (above). I had driven from Ilkley in Yorkshire with June and my twin sister Shirley, and stopped for a break before continuing home to Devon. We went for a short walk along the River Avon to stretch our legs and, although I had my oil pochade box with me, I felt almost too weary to paint.

However, when I saw this view with the distant trees and hay being collected, I just couldn't resist painting it. I didn't have my fold-up seat with me so I sat on the grass with my pochade box resting on my legs. I remember far-off days when it was easy to sit this way but I now find it extremely uncomfortable, especially while trying to support a pochade box as I paint! Nevertheless, I spent an enjoyable 45 minutes and at least my awkward position stopped me fiddling too much with my painting.

▲ EARLY EVENING, TEWKESBURY
Oil on primed Waterford paper
with an acrylic wash of Raw Sienna
25 × 30 cm (10 × 12 in)

*I was very pleased with the result of this painting and looking at it always takes me back to that journey with June and Shirley. Notice how the path leads you into the painting and gives movement and perspective. Incidentally, I have never sold this painting – June and I try to keep some work as mementos of our travels.*

## PAINTING EQUIPMENT

The most important aspect of travelling with painting equipment is to take the minimum and to make sure it is as light and portable as possible. Our basic equipment is listed on these pages.

For watercolours up to A3 size (42 x 29.7 cm/16½ x 11¾ in), June and I use the Travelling Watercolour Studio (shown below) which is lightweight and easy to carry. We also take A4 (29.7 x 21 cm/11¾ x 8¼ in) or A3 sketchbooks with us.

If we plan to paint larger watercolours, we each take a watercolour box (above right) plus a watercolour pad or watercolour paper on a lightweight board. We also pack a water container, brushes, a pencil and a putty eraser.

On touring holidays, it is best to paint no larger than A4 or A3 in size, or you may run out of painting time and be disappointed. Our largest painting size for a full morning or afternoon session outdoors is 38 x 50 cm (15 x 20 in) – we don't paint watercolours larger than this outdoors.

I always take my oil pochade box (below right) when we are touring. The largest oil painting I normally work on is 30 x 40 cm (12 x 16 in) and the smallest is 15 x 20 cm (6 x 8 in). If I am painting from a base, or if the car is nearby, I use an easel to work on. This allows me to stand or sit while I work, and to do larger paintings.

If you work in oils, remember that you are not allowed to take turpentine or white spirit on an aeroplane. When going abroad, contact your hotel to see if they can order some for you. If you are self-catering, you should be able to get this from the local hardware shop.

## WATERCOLOUR

### COLOURS
French Ultramarine, Crimson Alizarin, Yellow Ochre, Cadmium Yellow Pale, Cadmium Red, Hooker's Green No. 1, Coeruleum Blue

### BRUSHES
Daler-Rowney Series 40 Sable: No. 10, Series 43 Sable: No. 6, Dalon Series: D99 'Rigger' No. 2

### PAINTING SURFACES
Waterford watercolour paper, Bockingford watercolour paper, cartridge drawing paper

### OTHER ITEMS
2B pencil, putty eraser

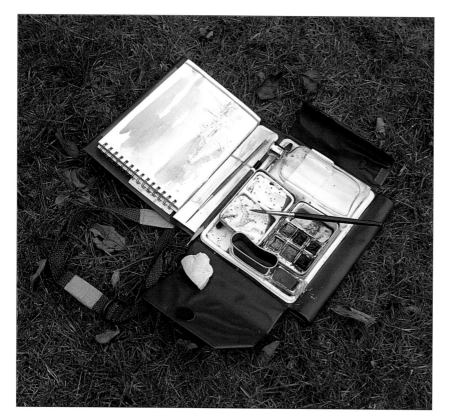

◄ *We find the Travelling Watercolour Studio, which I designed myself, indispensable for outdoor work. It is totally self-contained and you can even use it standing up. The contents are: six Daler-Rowney Artists' quality Watercolours (my colours) in a removable aluminium paintbox, a No. 5 sable brush, a spiral-bound Bockingford Watercolour Paper pad, 13 × 18 cm (5 × 7 in), and a pencil. It has a rustproof water bottle and water-cup holder. All this is held together in a tough PVC waterproof case with carrying strap and weighs only about 500 g (1 lb).*

*◄ We use this size watercolour box when working on large paintings as it has larger mixing palettes than the Travelling Studio. It contains twelve whole pans but we normally only use the colours listed on the opposite page.*

*▼ This small oil pochade box carries all I need for paintings up to 25 × 30 cm (10 × 12 in).*

## OIL

### MAIN COLOURS
Cobalt Blue, Crimson Alizarin, Cadmium Red, Cadmium Yellow, Yellow Ochre, Viridian, Titanium White

### EXTRA COLOURS
Coeruleum Blue, Cadmium Green, French Ultramarine, Lemon Yellow

### BRUSHES
Daler-Rowney's Bristlewhite Series B48: Nos. 2, 4 and 6, Cryla Series C25: Nos. 8 and 10, Sable Series 43: No. 6, Dalon Series: D99 'Rigger' No. 2

### PAINTING SURFACES
Canvas board, Waterford primed paper, canvas (medium grain), primed hardboard

### OTHER ITEMS
2B pencil, putty eraser, palette knife, Alkyd Medium, Gel Medium (both these products are used for speeding up paint drying time), turpentine or Low Odour Oil Painting Thinners

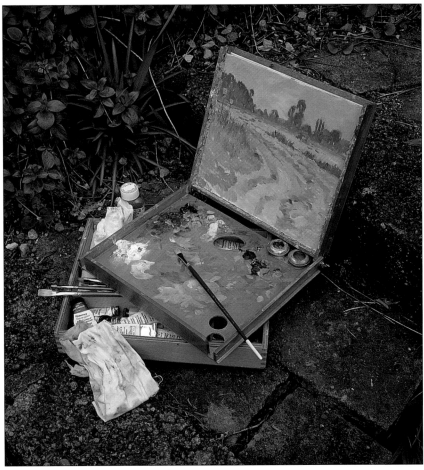

By courtesy of Saga Magazine

*◀ June and I don't always paint side by side! However, it is always more enjoyable if we like the same subjects and can paint within talking distance of each other. Seeing things through another person's eyes can also be very helpful and artistically stimulating. Both this photograph and the one below were taken near our home in Dawlish.*

While working on the book, it suddenly struck us what a good idea it would be for students to take stage photographs of their work. June and I regularly take outdoor painting courses but we had never thought of suggesting this before. From our own experience, we know what a simple yet instructive way of teaching yourself this is. Why don't you try it? By taking several photographs at different times during your painting process, you can use these later to remind you how your painting progressed and how you managed to achieve certain effects.

Many of the smaller paintings that June and I did for this book were worked very simply and we feel that these are just as important as our larger paintings. Sometimes they were done this way because of time restrictions but often it was simply how we wanted to approach the subject. When we were in Tuscany, June visited an olive grove and painted a quick impression of the trees (above right). Watercolour has a unique quality when it has been applied quickly and confidently working from nature. It doesn't matter whether you call this type of work a sketch or an exercise, it is still a watercolour painting in its own right.

## SEIZING THE MOMENT

I am constantly telling students (and myself!) that when you see something that inspires you, you should paint it immediately. On another day, the light will be different, the atmosphere may have changed or something could be obstructing your view. You may not even have your paints with you – I could go on and on!

The painting (opposite) was nearly one of the ones that got away. June and I had taken twenty students on a painting course to the Dordogne. We were staying at La Roque-Gageac and the view from the other side of the river had inspired most of us from the moment we arrived. We had two weeks, so it seemed that time was on our side. Eventually, one afternoon, we organized a boat to take us across the river and we all had a fabulous time.

By courtesy of Saga Magazine

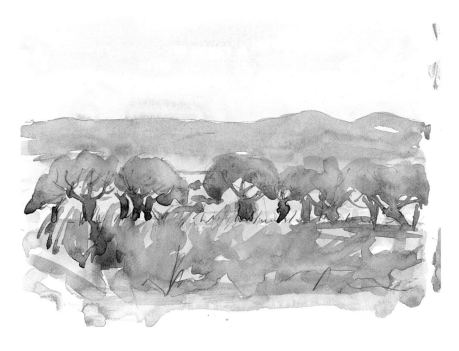

◀ TUSCAN OLIVE GROVE
Watercolour on cartridge paper
14 × 20 cm (5½ × 8 in)

*Never be afraid to simplify things,
as June did with this grove of
olive trees. Always try to observe
your subject very carefully first,
looking for the important shapes
that will give the character of the
scene, then simplify these.*

I did the painting as a demonstration for some of the students in our party (you can actually see the other students working on the left of my picture).

That night we had severe thunderstorms and it rained for the whole of the following day. The result was that the entire riverbank from which we had been painting was submerged in swirling, rushing water and it was still that way when we left seven days later. We could so easily have missed that memorable afternoon. Remember, when you are inspired by a scene, paint it there and then!

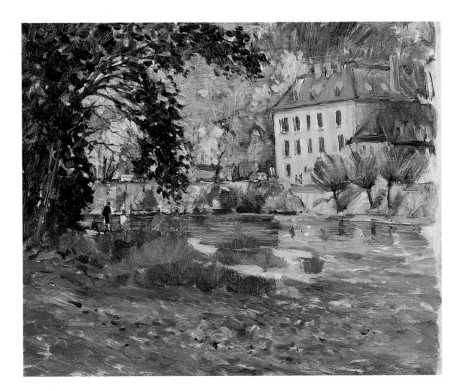

◀ THE DORDOGNE AT
LA ROQUE-GAGEAC
Oil on primed hardboard
25 × 30 cm (10 × 12 in)

*I feel that I achieved the warm
soft green and ochre colours of
the scene but think the large
building is falling to the left a
little! Notice how the water
merges with the green grass and
the shingle bank. This is because
the surrounding colours are
reflected into the river and very
little 'blue' sky is reflected.*

When writing this book, June and I decided to group our paintings in a way that would make it easy for you to find answers to your painting problems rather than in the order that they were done on our travels. To create these categories I have taken the most important aspect of each painting, such as the subject used or the conditions under which it was painted. Naturally, some paintings could come under more than one heading – the painting on page 97 in the chapter on buildings could quite easily have been placed in the one on painting water (page 70).

## TAKING A PHOTOGRAPH OF YOUR SCENE

Where possible, a photograph of the scene is reproduced next to our paintings, to help you to see how June or I interpreted these. Actually, when you work from photographs at home, it is worth studying them against finished paintings. You will find that you often need to emphasize subject matter. A perfect example of this is shown on page 35, where the windmill in my photograph is tiny and almost indistinct. In the painting I have made it much larger – in fact, how I actually saw it. If I had used the photograph to paint from back home, unless I also used my memory or some artistic licence, the windmill would have been too small in the painting and the composition would have been wrong. When painting from photographs, remember to use your creative and artistic skills to interpret the scene as well. And, next time you are out painting, take a photograph of the scene and compare it with your finished painting to see the difference.

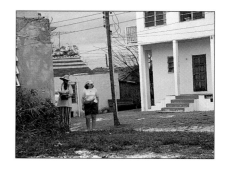

▲ *June sketching in the Bahamas.*

▼ FIRST STAGE

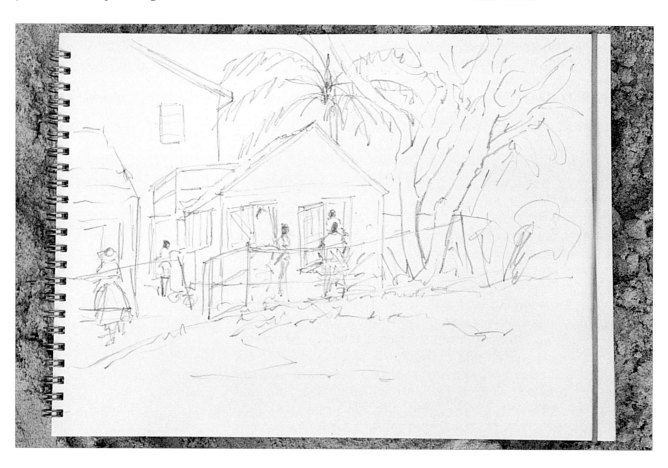

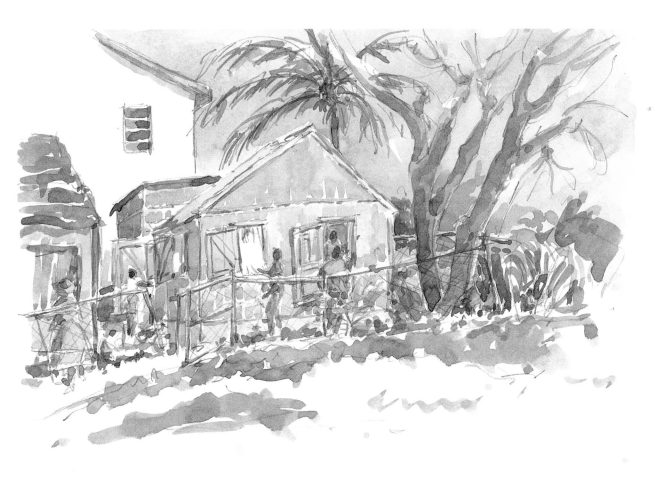

## SKETCHING OPPORTUNITIES

Waiting time can be sketching time as well. Whenever we are on our travels, there are always plenty of opportunities for sketching while waiting at airports or queuing for local tourist attractions. It is very important to take advantage of these useful sketching moments because they keep your eyes and pencil trained, as well as making wonderful holiday mementos. Just think, you will be the only person with a smile on your face, as you take advantage of that unscheduled stop on the journey!

Whether you travel just a few miles from home or to the other side of the world, the most important thing to remember is to enjoy your painting. Sometimes I can be just as inspired by a wet, grey day as I am by a bright, sunny one. Always look at the scenery around you and let it inspire you.

When we were in the Bahamas, filming our television series *Crawshaw's Sketching & Drawing Course*, June was determined to paint the old, traditional dwelling (above). The first stage drawing of it is shown (left). It was a very hot day and she had to stand up to paint it but she says she felt so exhilarated that she really enjoyed doing it. If you can generate this kind of excitement for your painting when you work outdoors, you will have some wonderful times ahead of you. June and I hope that we have conveyed some of the joy of painting through this book and that you will learn from our painting experiences and enjoy sharing them with us. Happy painting!

▲ ON HARBOUR ISLAND
Watercolour on cartridge paper
20 × 30 cm (8 × 12 in)

*While we were filming in the Bahamas, we passed this scene on Harbour Island almost every day and, every time she saw it, June felt inspired to paint it. She finally found time on the last day we were there!*

# COPING WITH CHANGING LIGHT

The biggest problem an artist encounters when working outdoors is that natural light is constantly changing. The most obvious effect this has is on shadows. If you start a painting in the morning, the shadows that are cast will shorten as the sun moves higher in the sky. During the afternoon, they will become longer again. It is even more important to remember that they will start at one side of an object in the morning and move round to the other side in the afternoon.

## WAYS OF WORKING

One way to cope with this problem is to start and finish your painting in one morning or afternoon session. Naturally the shadows will move, but they will stay on one side of your subject during your painting. If you intend to paint all day, another way to overcome this problem is to draw in the cast shadows at the start, or to make a note of them on your sketchpad before you start your painting. A third method is to paint for two or three hours each day at the same time, and in the same weather conditions, until the painting is finished. This doesn't make sense when you are travelling, nor does it work very well with watercolour. I believe a watercolour painting worked outdoors should be completed in one sitting. Over the years, June and I have found that, when travelling, we take from half-an-hour to three hours to complete

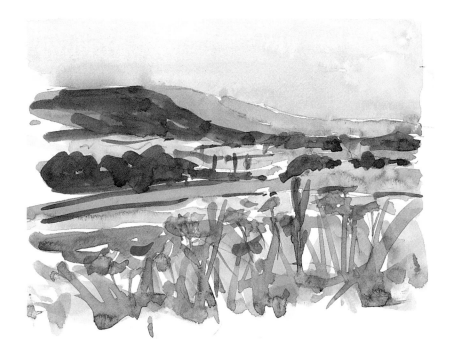

◀ DISTANT VIEW, PROVENCE, FRANCE
Watercolour on cartridge paper
15 × 20 cm (6 × 8 in)

*June worked this sketch very freely. She wasn't looking for detail. The object was to capture the patterns of moving sunlight and shadows on a distant landscape.*

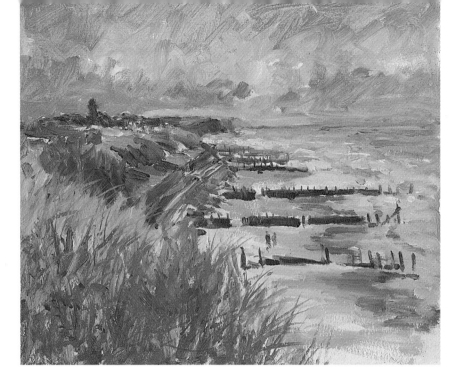

◀ FROM ECCLES BEACH, NORFOLK
Oil on primed Waterford paper
with an acrylic wash of Raw
Sienna
25 × 30 cm (10 × 12 in)

*I positioned the horizon first with
my No. 6 sable brush and a
turpsy mix of Cobalt Blue and
Crimson Alizarin, then drew in
the breakwater, the sea and the
distant village. I wanted to
capture the dark shadow areas
and bright sunlit areas on the
distant sea and beach. I left a
lot of Raw Sienna wash
unpainted for the sunlit parts.
I couldn't make out the tall
building in the distance. It
looked as if it had a thick ledge
around it so I painted it that way.
When we drove through the
village of Happisburgh on our
way home, we saw that it was the
church tower with a platform of
scaffolding around it!*

paintings outdoors in watercolour or oil. Keeping to this timing helps to eliminate the problem of changing shadows.

Another problem with changing light is the effect that clouds have when they go over the sun. The landscape can change dramatically as one area goes from bright sunlight into rich, dark shadow. The best way to approach a painting in such conditions is to sit and watch and then decide which pattern of light and shadow inspires you most.

## DIFFERENT LIGHT EFFECTS

When we were in Provence a few years ago, June was fascinated as she watched the changing light patterns on a distant landscape. She worked very quickly and painted four different sketches with different light effects, one of which is shown (left). The red poppies in the foreground help to lend scale and these contrast well with the greens in the landscape.

I did the oil painting on Eccles Beach in Norfolk (above) on the same type of day. It was very windy and I had climbed to the top of some sand dunes. When I saw the view, I knew I had to paint it. I rushed back down to the beach and, grabbing my pochade box and fold-up chair, left June painting the rough sea and climbed back to the top again.

However, when I sat down, I couldn't see a thing because the tall grass totally blocked my view. In my excitement, I hadn't checked this out when I first stood looking at the view. Ten minutes later June came up to see how I was getting on and I still hadn't started! I was trying, without success, to find a vantage point where I could see the view while sitting down.

I finally decided to paint standing up, although it meant I had to hold my pochade box with the painting and my palette in one hand. There was nothing to lean against and I was working in a gale-force wind. It took an exciting but agonizing 45 minutes but I knew it was worth it. I was very happy with the painting, and pleased that I had been able to master the situation.

When June and I were in Brittany, we visited the town of Pont-Aven, where the French Impressionist artist Gauguin spent a lot of time painting with his friend Emile Bernard.

It is a beautiful town, with a tidal river running through the centre and offers a good selection of art galleries as well as a Gauguin Museum. With all its different views and aspects, it took us some time to choose views to paint for the next two demonstrations. Eventually, we both decided on the same scene.

It was late spring and the air was fresh, with a strong breeze blowing heavy rain-threatening clouds across the blue sky. While we were painting, we had to run for cover during one heavy shower but, although June and I got wet, we saved our paintings!

### FIRST STAGE
The sun kept going in and out so I had to decide how I wanted the sunlight falling on the scene in my painting. When I saw a bright blue patch of sky over the distant trees and the sun lighting up the left of the right-hand building and the water cascading over the rocks, I decided to paint it this way. Naturally, the sun continued to go in and out but the painting took over two hours and the same sunlit scene reappeared on many occasions.

I drew the scene with a No. 6 sable brush and a turpsy mix of Cobalt Blue and Crimson Alizarin.

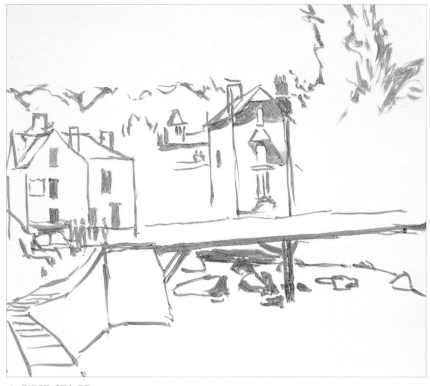

▲ FIRST STAGE

The main feature to establish was the footbridge, which worried me a little because it sloped down to the left in real life and looked slightly wrong on the painting.

I decided to leave out the white yacht and the mast that was directly in front of me.

### SECOND STAGE
The next stage was very enjoyable. Using a No. 4 bristle brush, I painted the whole of the picture using plenty of turps mixed with the paint. I worked it like a very free watercolour. The object of this was to block in areas and get the tonal

▼ SECOND STAGE

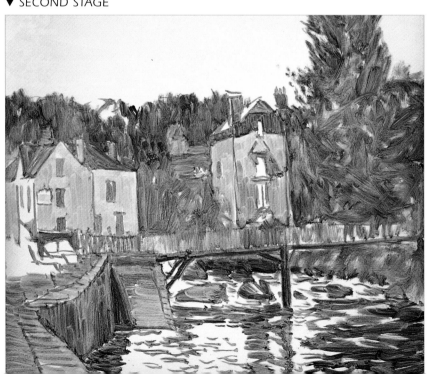

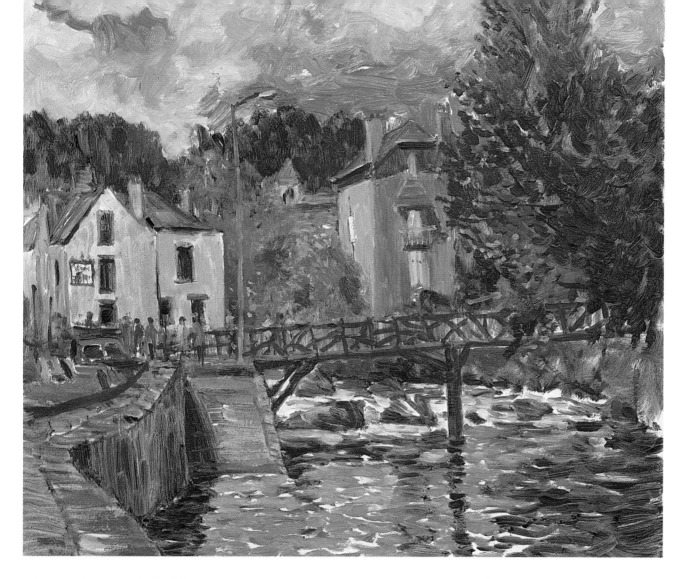

relationships correct. At this point I wasn't concerned about trying to recreate the exact colours in the painting.

## FINISHED STAGE

I used thicker opaque paint for this stage, starting with the sky. I painted the distant trees and fields next and then the central building. It was important to establish this building as it played a dominant part in the composition.

I left some areas untouched from the first stage so that they showed through in the painting.

The illusion of sunlight is helped by the bright blue sky, the yellow sunlit building and the way the white and pale blue water contrasts with the dark shadows.

▲ THE FOOTBRIDGE AT PONT-AVEN, BRITTANY
Oil on primed hardboard
25 × 30 cm (10 × 12 in)

▼ *This detail from the finished stage shows how the contrast of the shadows on the rocks and the dark-coloured bridge against the white painted brush strokes of the water helps to give the illusion of sunlight.*

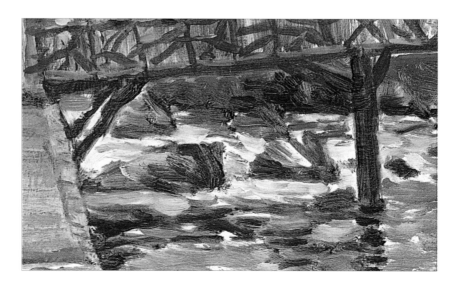

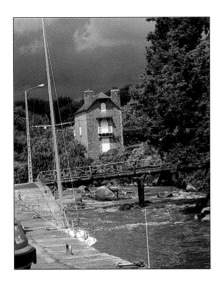

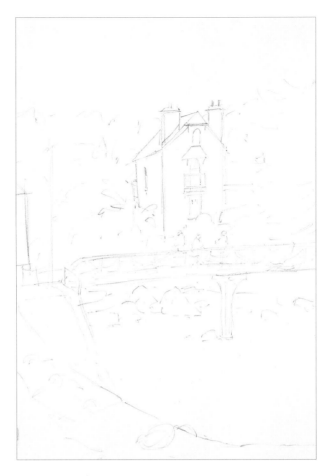

◀ FIRST STAGE

June chose to paint only part of my scene on the previous page for her watercolour. She also had more problems with the rain than I did.

There was a heavy downpour just after she had painted in the sky and, as she held the painting out of the rain, the wet colours ran, creating some strange streaks in the sky. The only way one can avoid this happening is to anticipate a rainshower early enough – it is all part of the adventure of working out in the elements!

## FIRST STAGE
June used a 2B pencil to draw the scene, starting with the house. Once this was done, she put in the bridge (adding some people as they walked over it). Next she drew in the quayside and rocks.

## SECOND STAGE
The sky was painted first and then the greens for the trees. Some children congregated at the end of the bridge and June drew them but didn't paint them in until after she had finished the trees. She then painted the first wash on the bridge and rocks.

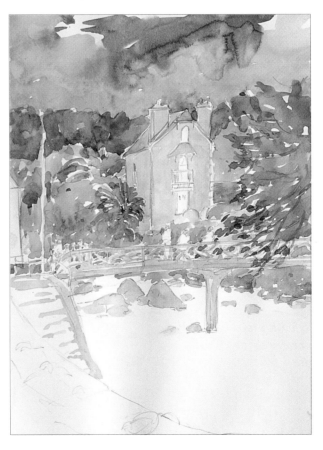

◀ SECOND STAGE

## FINISHED STAGE

June had less contrast on her building than mine as the sun had moved round. The building in my painting is also at more of an angle. But June's treatment helped her watercolour, especially with the long diagonal shadows. June darkened the trees behind the house and this gave contrast and made the house appear sunlit.

The water was painted with just one wash and June changed the colours as she worked down, letting them run together, wet-into-wet. She also left some unpainted white paper to represent movement.

Both June and I painted in the water last – and we both got a shock. By this time it had risen and completely covered the rocks so we had to use our memory of a couple of hours earlier to put in the water as it had been when we started our paintings. Time and tide waits for no man – not even artists!

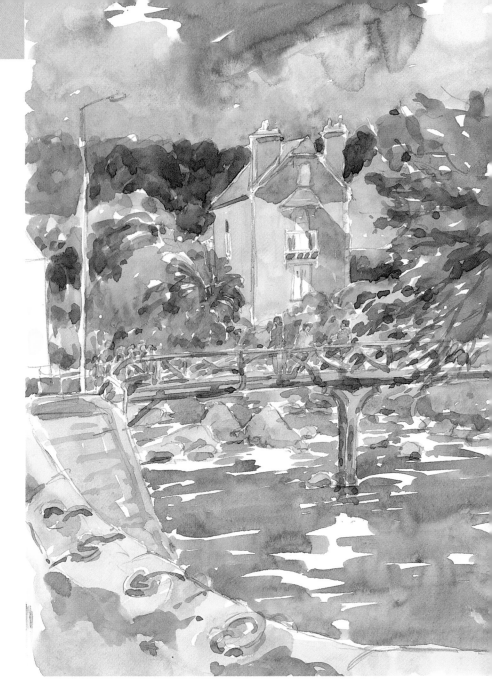

▲ PONT-AVEN, BRITTANY, FRANCE
Watercolour on cartridge paper
28 × 20 cm (11 × 8 in)

▶ *In this detail from the finished stage, you can see how the well-defined shadows on the front of the building give the illusion of sunlight. Also, the dark background contrasts with the light side of the roof and wall of the house, giving more prominence to the building.*

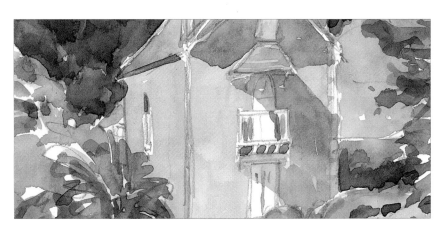

▲ *On the bank of the River Thurne at Potter Heigham in Norfolk.*

The painting (below) was done in very fast-changing light. It was late autumn and June and I had gone for an afternoon walk along the river bank at Potter Heigham in Norfolk. The sky was pearly-grey and overcast, and there wasn't a breath of wind. We had taken our sketchbooks and Travelling Watercolour Studios more as a gesture than for a serious sketching trip as it was late and the light wasn't good. However, I saw the view (left) and felt inspired!

## NATURE'S SUBTLE MOODS

To be able to stand, totally absorbed and excited, as you paint a field with marsh grasses, telegraph poles and an old reed cutter's cottage on a damp, overcast, late afternoon in autumn might seem rather strange to some people. But this is the sort of thing that happens when you are out painting. Whether you are a professional or an amateur artist, it is a marvellous feeling to capture nature in all its subtle and wonderful moods.

The first thing I did was to take a photograph for the book because the light was fading fast. I only had about 30 minutes before darkness set in. In situations like this, you must decide to work small and fast. Although in a hurry, I positioned the cottage and surrounding trees carefully and shaded the tones in with pencil. Then I quickly got out my paints and put some simple washes over the drawing. The satisfaction I got from the results of that half-hour's painting was enormous. But remember, you must be prepared to work fast in this type of changing light.

▼ THE REED CUTTER'S COTTAGE, POTTER HEIGHAM
Watercolour on cartridge paper
20 × 28 cm (8 × 11 in)

*The light was fading fast as I did this painting.*

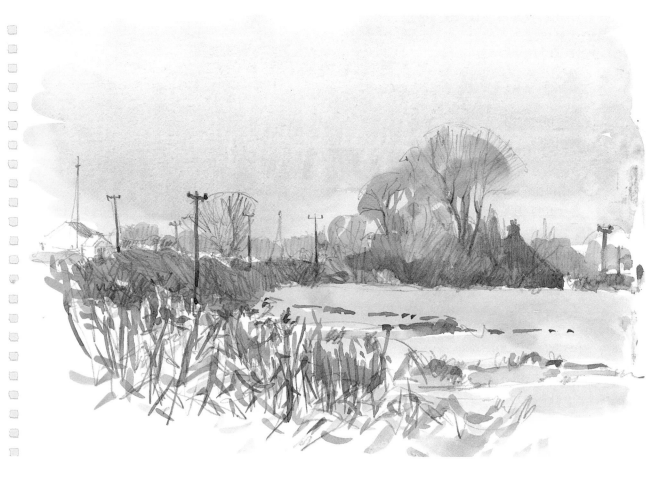

## DRAMATIC COLOUR CHANGES

June had to work even faster when she did her watercolour (above). We had been sketching on the beach at Dawlish and it was getting late. However, just as we were packing up, we saw this very dramatic sunset and June decided to stay and paint it.

A sunset is perhaps one of the most difficult subjects to capture – not only is the light changing quickly but you also get some dramatic changes in colour at the same time. To paint sunsets or sunrises successfully, you have to work extremely fast and concentrate on the overall image, not on detail. More realistic paintings can only be done in the studio from photographs, sketches and memory, for obvious reasons, but it is important to work from nature to familiarize yourself with the sky's many different moods.

June didn't do any pencil drawing before she started painting. She began by applying a wash from top to bottom, starting with pale French Ultramarine, changing to Cadmium Yellow Pale and Crimson Alizarin and finally going back to French Ultramarine for the town. She also added a little Yellow Ochre for some of the houses. This was all done wet-into-wet.

When this was dry, she painted in the dark clouds to create a strong contrast to the sunlit clouds. It was important to paint in the silhouette of the trees and suggest some tree trunks. Together with a suggestion of windows in the buildings, these give dimension to the sky and make the whole painting understandable. Notice that June didn't put any other detail into the painting.

▲ SUNSET OVER DAWLISH
Watercolour on Bockingford
200 lb paper
20 × 28 cm (8 × 11 in)

*June needed to work quickly to capture this dramatic sunset.*

## CAPTURING SUNLIGHT

There are many different ways of portraying sunlight. You can, for example, paint strongly-cast shadows to contrast with bright colours in the sunlit areas of your picture. If you paint a scene looking into the sun, this will make objects appear in silhouette and exaggerate the sunlit areas behind them. However, the best way to learn about creating sunlight in your paintings is to go out and work from nature and paint what you see.

June and I visited Great Yarmouth during the summer of 1995 and decided to paint on the beach. Unfortunately, we soon discovered that it was far too hot and bright to work on the sands so we looked for a place to paint in the shade. We eventually found the perfect spot under an awning on the promenade where we could sit in the shade and still have a full view of the beach. There was only one thing missing from our scene and that was people (it was still quite early) but eventually a few sun worshippers started to arrive and June began her painting (right).

## USING STRONG SHADOWS

June's beach painting gives the illusion of sunlight and this has been achieved by putting in strong shadows. The figures were painted with a mix of Cadmium Yellow Pale and Crimson Alizarin. When this was dry, hard-edged shadows were painted on them, using a mixture of French Ultramarine and Crimson Alizarin and a touch of Yellow Ochre. The deck chair on the left was painted with its stripes and, when this was dry, the dark shadow was painted over it. The contrast between the shadow and the sunlit areas on the deck chair gives a perfect illusion of sunlight. The crisp cast shadows on the beach and promenade are also very important.

If I had been working on this painting in the studio, I might have been tempted to make the promenade much darker than the beach to give contrast. But I think June's method works better because the whole picture looks as if it is flooded with sunlight, which is how she saw it in real life. It is important to

*Conditions are rarely absolutely perfect when you are working outside but that's what makes it so exciting. Remember to pack a large amount of patience in your paintbox! These are the notes June wrote at Great Yarmouth as she did her painting (right):*

**'Very hot. Beautiful day. Found a seat in the shade. Started drawing deck chair with chap happily reading in it but halfway-through he moved away. Never mind – carry on! Just finished the drawing. A group put up more deck chairs right in front of my view. Painted looking around them! They went after 10 minutes. Alwyn moved their deck chairs. Easier now, carried on with painting. Man stood in front of me for ages. Couldn't see and had to stop working. Man now gone, so able to start painting again. Beach a very pinky mix of Yellow Ochre and Crimson Alizarin.'**

*◄ Shadows are important to help to give the illusion of sunlight and, usually, the stronger the shadow, the brighter the sunlit areas will appear. Here, the deck chair colours were painted first and then the shadow colour was added when these were dry. You can see how the contrast between the sunlit and the shadow areas gives the impression of strong sunlight.*

▲ THE BEACH AT GREAT YARMOUTH
Watercolour on cartridge paper
20 × 28 cm (8 × 11 in)

work outdoors from nature as much as possible – you will always capture some magic in your painting that would elude you in the studio.

While June was painting, I was busy painting the view of the pier (reproduced on page 69). After lunch we saw a poster advertising the circus and decided, on the spur of the moment, to go to the afternoon performance and do some sketching. We hadn't been to a circus for 30 years and neither of us had sketched one before. It certainly was an entertaining spectacle. We were treated to two hours of non-stop flashing lights, laser beams, stereophonic sound effects, music and thrilling action.

However, it was virtually impossible to sketch. When the lights were concentrated on the ring, it was too dark, and when the lights were beamed into the audience, they flashed in your eyes. I gave up trying after a few sketches but June lasted longer, working virtually in the dark. A couple of her sketches are reproduced on pages 83 and 84.

We came out after the performance feeling like two excited school children who had been to the circus for the first time – well, it certainly had changed a lot in the last 30 years! Then we did some more pencil sketches from the promenade and finally bought fish and chips and, sitting on the now almost-empty beach, had a feast fit for a king. It was a lovely way to end another wonderful and memorable painting day.

▼ *June took this photo as I was finishing my fish and chips on the beach.*

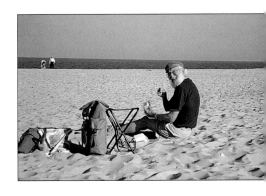

June's painting of this old shed shows how a very simple subject can be used to capture sunlight and freshness without overworking or painting in unnecessary detail.

When we returned to our cabin on the Norfolk Broads after a day out painting, June was inspired when she saw the evening sunlight on the shed and the rich, deep shadows across the grass.

## FIRST STAGE

June had to work quickly as the sun was going down and the shadows were changing the whole time. She started by drawing the shed and its immediate surroundings with a 2B pencil.

She then started painting, putting in the cast shadows of the fence on the left side of the shed, while they were still there! The sky was painted next – notice how she left unpainted white paper for some clouds. The windows were also painted at this stage.

You can see from the photograph that I took of the first stage (above right) that the paper June was working on was 'cockling' as she worked. Although this is exaggerated by the way the sunlight fell on it when I took the photograph, it does show very clearly how

cartridge paper can and will cockle. However, it is still a very practical surface to work on and it is worth persevering with. Cartridge paper will flatten as it dries and June and I use it for over 70% of our smaller outdoor watercolours.

## FINISHED STAGE

The grass and bushes were painted next using a mix of Hooker's Green No. 1, Cadmium Yellow Pale and Yellow Ochre. Then the rusty water tank was painted with Yellow Ochre mixed with a little Crimson Alizarin.

When this was dry, June painted in the shadow areas using a varying mix of French Ultramarine, Crimson Alizarin and Yellow Ochre. These were painted very freely with a watery mix, using a No. 6 sable brush. June left the sunlit side of the shed as unpainted paper to give the maximum effect of sunlight.

June had to work fast to capture the sunlight. The painting took her 50 minutes and she was very pleased with the result.

▲ FIRST STAGE

*The photograph for this stage was taken at sunset – notice how the paper reflects the changing light.*

▼ *June studying the old shed and deciding how she was going to paint it.*

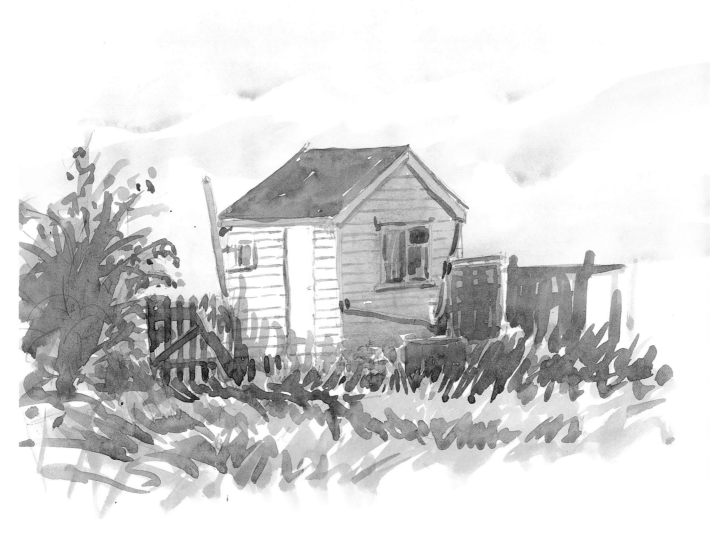

▲ THE OLD SHED
Watercolour on cartridge paper
23 × 33 cm (9 × 13 in)

◀ *In this close-up detail, you can see that, again, it is the shadows contrasting against the light-coloured areas that give the illusion of sunlight in this painting. Notice how freely June has painted these but remember that first she had to carefully observe them.*

We had decided to paint bluebells for the book and so, one spring morning, we set off to a local beauty spot where there is always an abundance of bluebells. On the way there we saw bluebells in full bloom in the valley but, when we reached our chosen painting spot in a wooded area on top of a hill, there wasn't a single bluebell in flower! We were very disappointed but decided to paint trees, and try for bluebells another day. These tree paintings are illustrated on pages 50–54.

However, when we arrived back at the wood two weeks later, it was covered in a carpet of bluebells. We were miles from habitation and hadn't expected to see another soul as we painted for the book. We should have known better – there were easels growing out of the bluebells everywhere! The local art group from Sidmouth, together with their tutor, had also decided to paint bluebells that day. There's never a dull moment when you're working out-of-doors!

## FIRST STAGE

I had given the primed hardboard a wash of acrylic, Raw Sienna mixed with a little Crimson. I used a No. 6 sable brush and a turpsy mix of

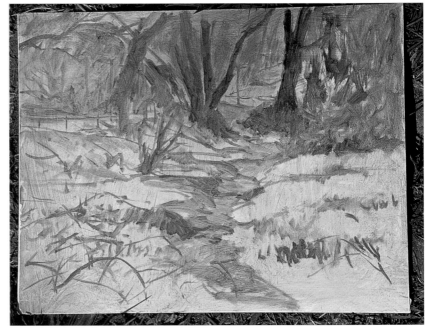

▲ FIRST STAGE

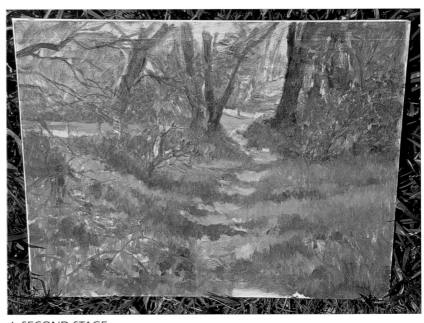

▲ SECOND STAGE

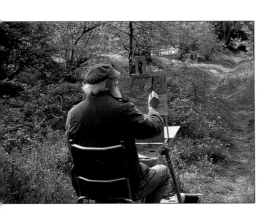

Cobalt Blue and Crimson Alizarin to draw the main features. Then, using a No. 2 bristle brush, I continued adding a little Cadmium Yellow to establish the tree trunks and the path.

## SECOND STAGE

Using thicker paint, I now painted in the sunlit areas of the path and distant field and then the bluebells. I mixed Titanium White, French Ultramarine and a little Crimson Alizarin for the bluebells and painted these working the brush with 'downward' strokes. I then painted the strong horizontal dark shadows. At this stage, I felt I had captured the most important element in the painting – sunlight.

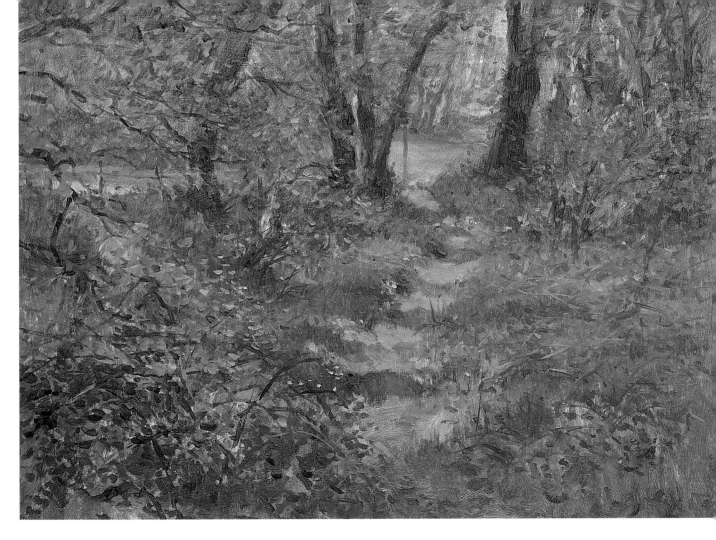

## FINISHED STAGE

I darkened the tree trunks and put more work into the leaves, working from the background to the foreground.

Notice how I left the gap in the trees very light in colour and unlaboured. This leads you through the painting and also helps to give the illusion of sunlight. In real life, this wasn't as bright as I have painted it, but this has helped my painting.

Don't forget when you are painting from nature that you can use your own creativity to achieve the results you are aiming for – but also remember not to go overboard!

▲ BLUEBELL WOODS, EAST HILL, DEVON
Oil on primed hardboard
30 × 40 cm (12 × 16 in)

▼ *You can see that some of the Raw Sienna underpainting shows through in places. This helps to unify the painting with a warm 'sunny' glow.*

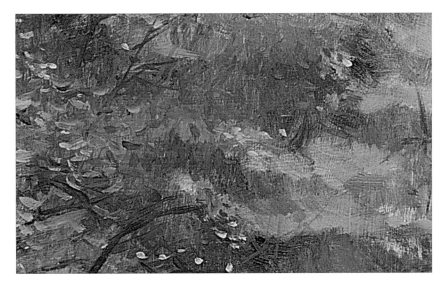

During our trip to Brittany we crossed the river at Bénodet to the very picturesque and busy little port. I painted the fishing boats that were pulled up on the beach (shown on page 117) but June decided to paint the local yacht club as they got their boats ready for a day's sailing.

As June painted, she was looking almost into the sun, which had a dazzling effect on the distant yacht masts and foreground boats. The yachts and their crews were moving all the time as they prepared to sail out to sea. It's amazing, when you want to paint them, just how quickly people can get ready and depart!

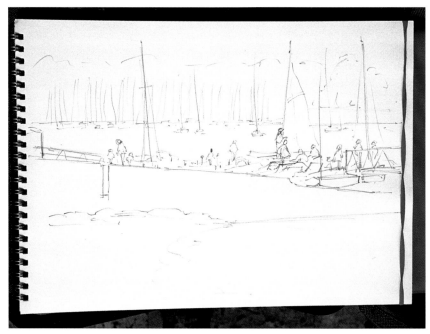

▲ FIRST STAGE

## FIRST STAGE
June did the drawing with a 2B pencil. She drew in the yacht sail and the figures around it first, so that she could fix her centre of interest while they were still there. By the time she was ready to paint, they had moved off!

She then drew the horizon and one or two distant yachts very simply with no detail, and then put in the harbour wall.

## SECOND STAGE
June painted in the distant trees first. She used a mix of French Ultramarine and Hooker's Green No. 1. Notice that she left all the masts as unpainted white paper – this was very important.

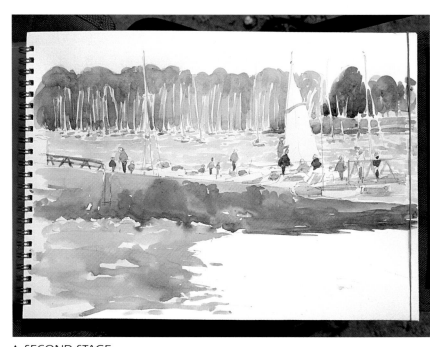

▲ SECOND STAGE

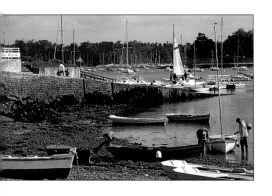

The river was painted the same colour as the trees and with horizontal brush strokes. June left white paper unpainted for the distant yachts and the movement on the water.

The figures were painted in next. Naturally, they had all changed position but June worked to her original pencil drawings and also used the people who were still on the quay as reference. Finally, she painted in the quay wall and beach.

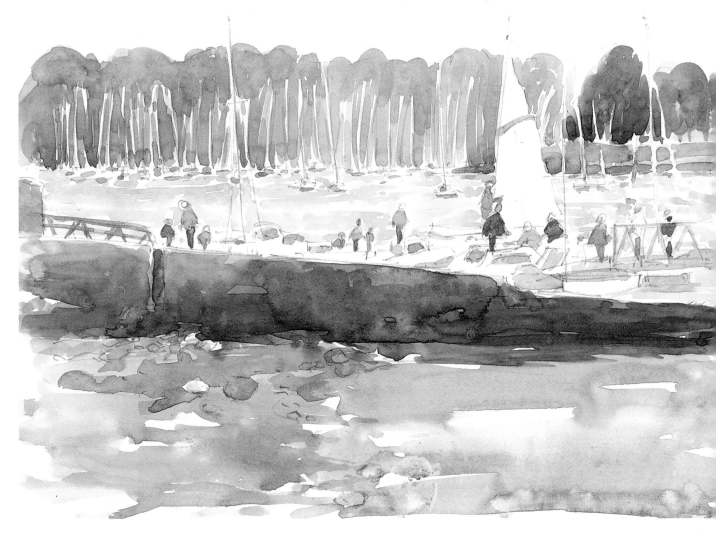

## FINISHED STAGE

June now painted the quay wall darker and added the water in the foreground and a shadowy area on the beach.

At this point there was a heavy rainshower and June and I had to stop work and scurry for cover under umbrellas and plastic shower coats – anything to keep the raindrops off our work! Once the rain had stopped, June looked at the scene and, seeing that the sun had gone in for at least the immediate future, decided she was satisfied with her painting and would call it finished. That's one way to stop fiddling!

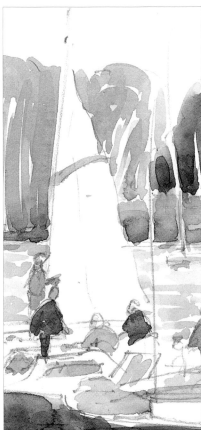

▲ YACHTS AT BÉNODET, FRANCE
Watercolour on cartridge paper
20 × 28 cm (8 × 11 in)

◀ *In this close-up detail, you can see how simply June suggested the people. Notice also how the edges of the yacht sail were worked very freely. Don't let straight edges become a worry – use the same freedom (brush strokes) for them as the rest of your painting.*

# WORKING
# WITH GREENS

E ven if they live in a very green country, many students find a 'green' landscape difficult to cope with. Their main problem is finding the correct variation of greens to make the picture. There is often a tendency to mix greens that are too bright, with the result that they do not lose their intensity as they recede into the distance.

Try this exercise. Stand in a field and put your hand in front of your eyes so you can't see the field but, looking over the top of your hand, you can see distant fields and hills. Look at them for about two minutes. Don't cheat! Then take your hand away. The field will look very green but the distant fields will look less green and more 'bluey' and the distant hills will look completely blue!

When you paint you must keep reminding yourself of this natural phenomenon. If you make your greens paler into the distance, this will also help. When you are outside, look around you and practise mixing the greens that you can see. Don't try painting a picture – just experiment.

## EXPERIMENT BY MIXING SHADES

Back home, spend time practising by mixing as many different shades of cool greens and then warm greens as you can from the three primary colours: red, yellow and blue. Above all, remember this painting rule: the nearer to you, the warmer the green; the further away from you, the cooler (bluer) the green. Naturally, there are always exceptions, particularly depending on climatic conditions, but if you use this as a general guide, it will help you.

◄ LOOKING FROM DOMME IN THE DORDOGNE, FRANCE
Watercolour on cartridge paper
20 × 28 cm (8 × 11 in)

*I started this painting when the mist was just clearing. Notice how the greens recede in colour and tone into the hills. When I had finished I took the photograph (above). By then, the mist had nearly lifted and the scene was a lot more dramatic. I would have preferred to have painted it in that mood but unfortunately we had to move on. Notice how I left the river as unpainted white paper.*

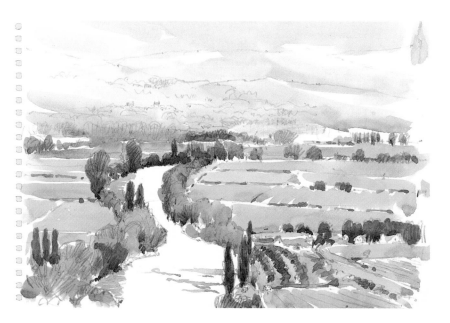

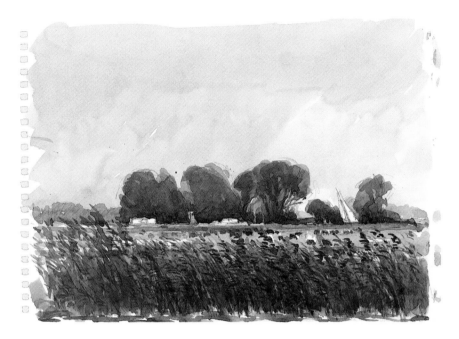

◀ GREY DAYS IN NORFOLK
Watercolour on cartridge paper
20 × 28 cm (8 × 11 in)

*This was painted on one of those grey, damp summer mornings, full of atmosphere and excitement for the artist but perhaps not for the holiday-maker! Although the trees and rushes are dark, you can still see that the left-hand trees in the distance are a bluey-mauve colour. The willows in the middle are a slightly warmer green and the rushes are warmer still. These colour changes are very subtle but important.*

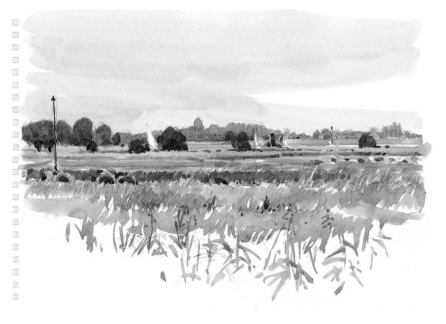

◀ ACROSS THE MARSHES,
POTTER HEIGHAM
Watercolour on cartridge paper
20 × 28 cm (8 × 11 in)

*The greens are brighter in this painting but you can still see that the greens are warmer in the foreground, become cooler in the distance, and finally are a bluey-mauve colour in the distant trees.*

▼ *In this detail, reproduced actual size, you can see the recession to cooler greens better.*

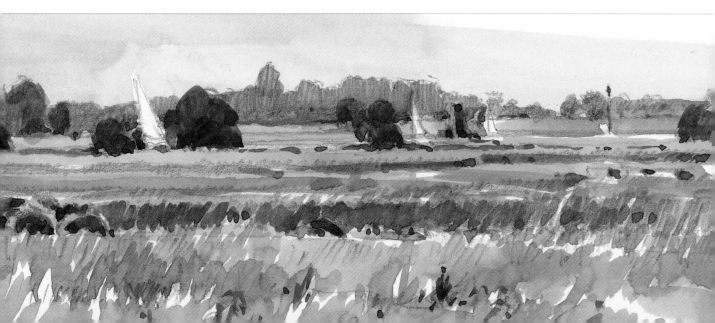

When June and I went out looking for a 'green' landscape to paint for this demonstration, I thought our quest would be easy. It was during one of our summer trips to Norfolk and everything was green. But I had a fixed idea of what I wanted to paint and, as I often tell students, this can be very unproductive. If you don't find the scene that you've set your mind on, try to forget all about it and paint what is actually there!

It took me 50 minutes of walking and looking around before I did exactly that, and it didn't help that June had started her painting and was already well under way before I realized the error of my ways. Only yards from where I had been looking, I saw the windmill and approached it with a completely open mind. It was a fantastic subject because it made a good composition and the landscape was full of greens. In fact, I don't think I could have found anything greener!

### FIRST STAGE

I used variations of the three primary colours and Viridian to mix the greens for this painting, but first I used my No. 6 sable brush to draw in the scene, using a turpsy mix of Cobalt Blue and Crimson Alizarin.

I painted the windmill first. Then I painted the distant trees and the reeds that go into the sky.

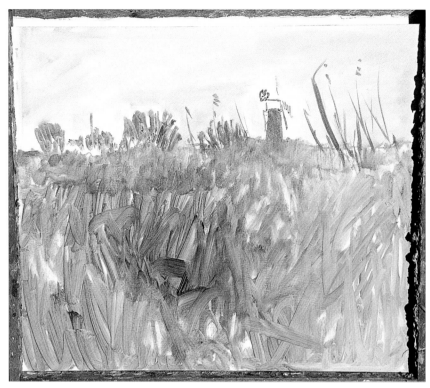

▲ FIRST STAGE

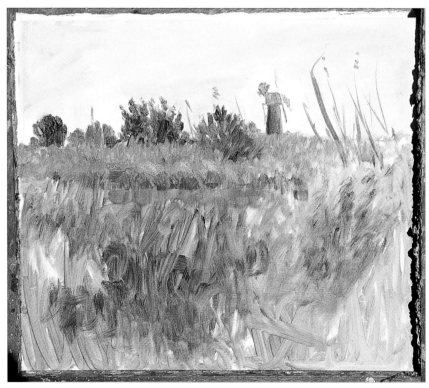

▲ SECOND STAGE

I then added colour and worked over the whole painting very freely, using mainly up and down brush strokes.

### SECOND STAGE

I then used thicker paint and worked over the distant trees and the windmill, and defined the

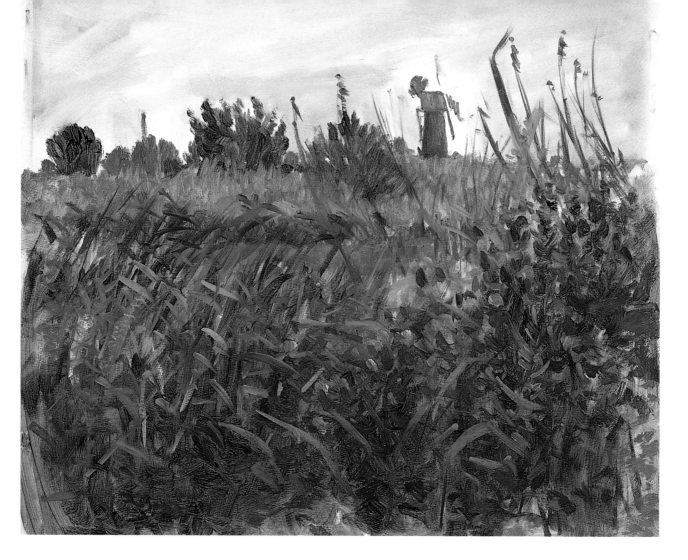

river a little more. I am still not sure if I should have made the river more distinct by making it slightly lighter in tone.

## FINISHED STAGE

For the rest of the painting, my mood kept swinging from elation to deep depression. The reason was that there was very little difference in form or colour to break up the foreground and, as this took up over half the painting, it had to work!

The secret of success is to keep on going and work through the disappointing times. If an area works, leave it and don't be tempted to fiddle with it. Only rework it if an area nearby changes in importance or form.

Remember at all times to show form by using dark against light or light against dark, and keep changing your greens, either tonally or by changing the colours. Lastly, remember that, even in a small area of reeds, a cool bluey-green will recede and a warm green will come forward.

It took 1 hour 50 minutes to do this painting and, despite my worries, I was pleased with it.

▲ RIVER THURNE, NORFOLK
Oil on primed hardboard
25 × 30 cm (10 × 12 in)

▼ *In this close-up detail from the finished stage, simple light-coloured brush strokes with a No. 6 sable brush helped to give shape and form.*

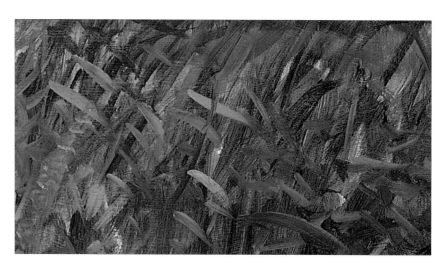

The scene that June had found while I continued to search frustratedly for the one I eventually painted for the previous demonstration was also a very green one.

Her comment to me was that the greens in her scene all looked fairly similar and it would have been better if there had been something – some cows, an old farm implement or a couple of people – to break up the greens. However, the breaks in the trees and the foreground reeds were good for the composition of the painting, as these led the eye through the picture.

One thing that June found while she worked was that the colours kept changing as the sun moved. This wouldn't have been so noticeable with a complicated, colourful scene like a harbour or a market but it was far more apparent in this case because most of the colours in her scene were the same. The colours June used for this painting were the three primary colours plus Hooker's Green No. 1.

## FIRST STAGE

June drew in the main features only, using a 2B pencil. She began with the row of trees, taking care where she positioned the 'gap', and then

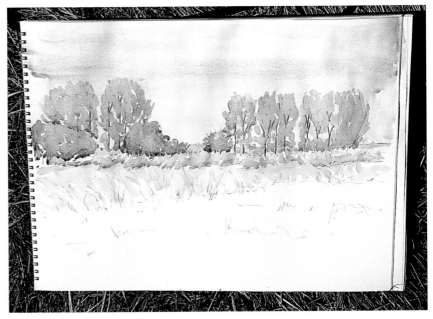

▲ FIRST STAGE

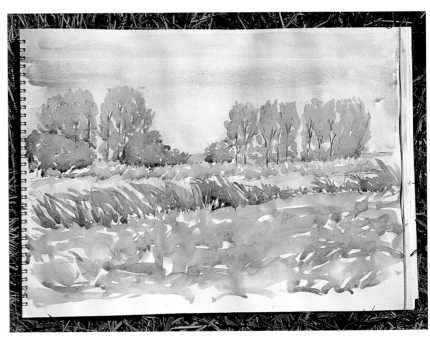

▲ SECOND STAGE

drew the line of reeds across the field.

The sky was painted just down to the horizon. When this was dry, June painted the distant trees on the horizon, using a very bluey-green.

She then painted the main row of trees, followed by the distant reeds and then finally the cut cornfield.

## SECOND STAGE

The reeds were painted next with a No. 6 sable brush, and then June painted the field. Notice how her brush strokes were done very freely. This gives life and interest to the field.

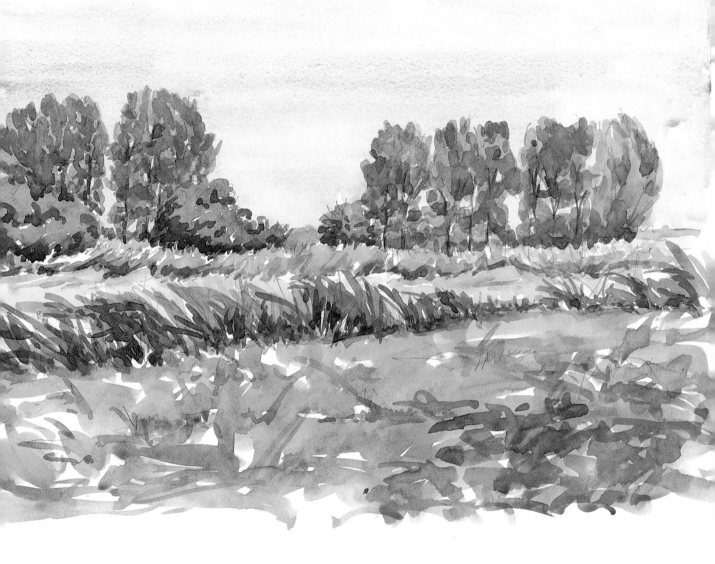

## FINISHED STAGE

June painted cool shadows on the main row of trees with a mix of French Ultramarine and Crimson Alizarin. She made the shadows much warmer for the smaller trees in front. Then, adding more Yellow Ochre and Crimson Alizarin, she painted a cast shadow from the trees in the foreground.

Although June mixed her greens from the three primary colours and Hooker's Green No. 1, for the bright greens she used Cadmium Yellow Pale in her mix instead of Yellow Ochre.

▲ ACROSS THE FIELDS, LUDHAM
Watercolour on cartridge paper
28 × 40 cm (11 × 16 in)

▼ *In this close-up detail, you can see the cooler greens at the base of the tall trees.*

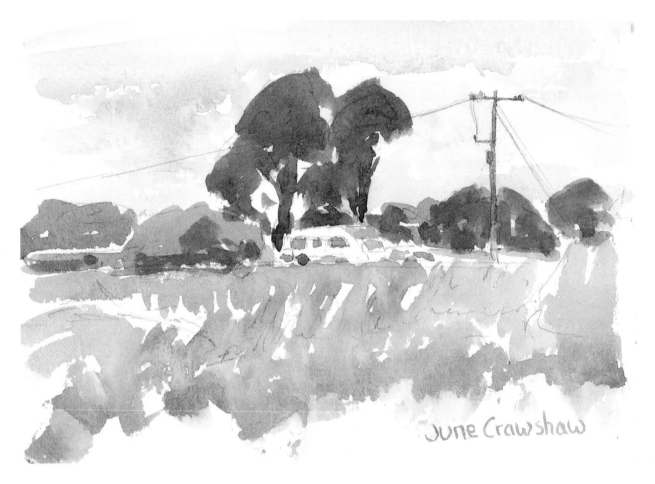

Perhaps the biggest obstacle we have to overcome when painting a 'green' landscape is in our minds. We know that fields, hills and trees are green but, as I have said before, when we are painting, no matter how green a tree or field looks, we must work distant greens less intensely in colour, or make them cooler than the nearer ones, which should be warmer. This will help to give perspective to the picture.

## USING DIFFERENT GREENS

In the simple little sketch of June's (shown above) you will notice that she painted a bright green in the foreground, a neutral cool colour for the middle distance trees (which were in shadow), and a bluey-green for the distant trees on the left. Incidentally, I do like the telegraph pole! A small sketch like this can easily be fitted into almost any time schedule when you are travelling.

I did the painting (opposite) looking towards La Roque-Gageac on the River Dordogne in France. I feel I could have made the distant trees bluer but the feeling of distance has been helped by exaggerating the cultivated fields in the foreground with their lines of crops. I also exaggerated the tall poplar trees and left the bend in the river as unpainted white paper. These things all help to lead the eye up to the castle on the left of the river. You will also notice how the pattern of the fields helps to take you into the picture.

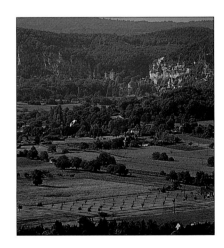

▶ LA ROQUE-GAGEAC, DORDOGNE, FRANCE
Watercolour on cartridge paper
28 × 20 cm (11 × 8 in)

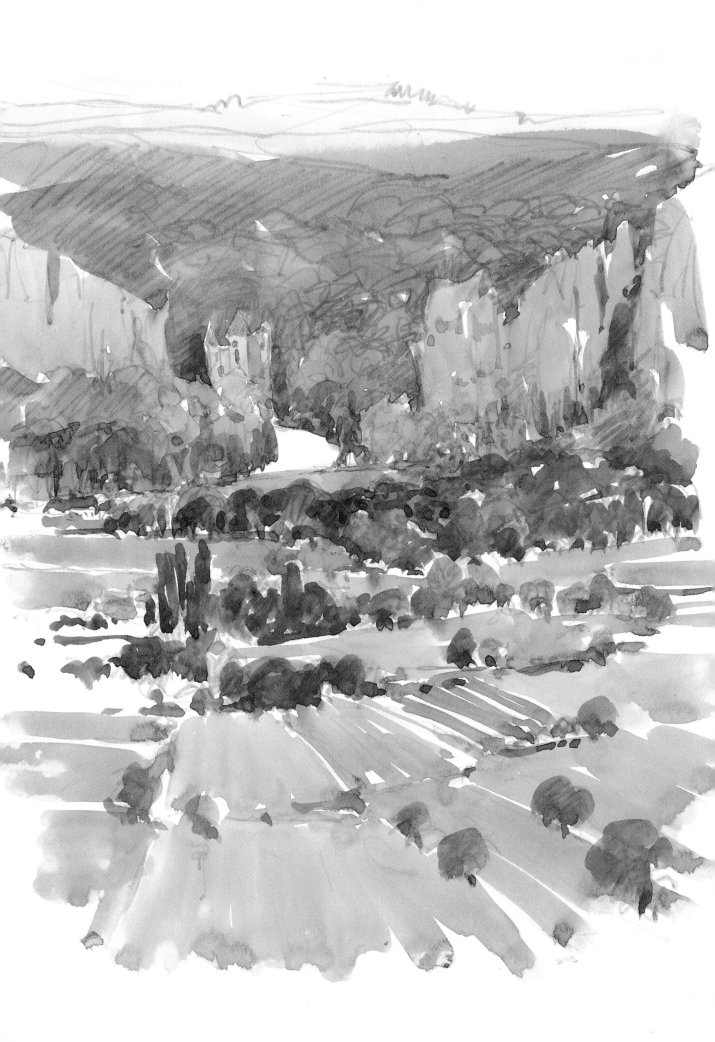

# CREATING
# ATMOSPHERE

When I see a scene that is full of atmosphere, I get very excited. It can be anything from a moody, gloomy landscape to a glorious sunset. Unfortunately most of these extreme moods of nature last for only short periods of time.

My late autumn afternoon painting of the old reed cutter's cottage on page 22 and June's painting of the sunset over Dawlish on page 23 are perfect examples of this. In fact, many of the principles discussed in the chapter on light also apply to painting atmosphere.

Naturally, all the paintings that we do need to portray atmosphere. If they didn't, they would lose their magic. When working from nature, if you paint a strong dark shadow against a bright area, it immediately conveys the impression of strong sunlight, while a weak, soft shadow implies that the sun is overcast. If you were painting a beach scene on a hot summer's day, you would convey the warmth of the day by the strong shadows, bright colours, a lost horizon on the sea through the heat haze, and so on. The atmosphere would also be captured by showing holiday-makers on the beach, windbreaks, a kite flying, people swimming and other beach activities.

## STUDY THE SCENE CAREFULLY
However, simply observing and painting what you see doesn't always work. You must study the scene carefully and decide which elements are bringing atmosphere to it. Then use your

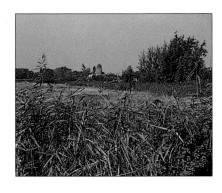

▲ *Looking across to the boatyard at Potter Heigham.*

▼ *In this close-up detail, you can see that my brush strokes are controlled rather than vigorous. This helped to give a feeling of stillness, with perhaps a little breeze suggested in the willows.*

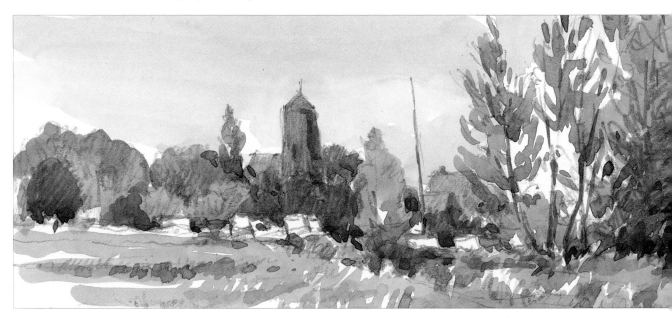

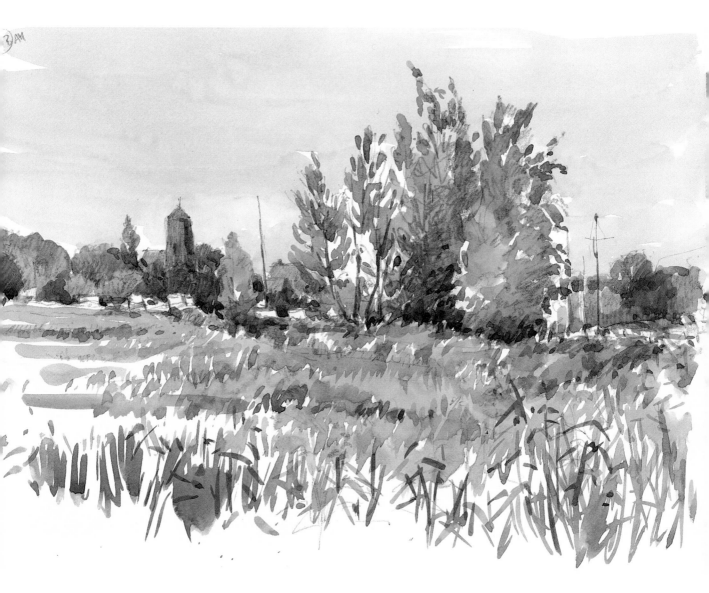

own creativeness and where you feel it necessary exaggerate one or more of these elements to emphasize and further the illusion.

I did the painting (above) looking out from the front of our cabin on the Norfolk Broads. The atmosphere was subtler and more difficult to capture than it was in the painting I did of the same scene on the next page. Here it was late morning, and the weather was warm, with a gentle breeze blowing. The shadows painted on the old windmill in the distance and the cloudless sky both help to suggest a hot, sunny day.

I left some small unpainted areas of white paper on the willow trees and put in some single brush strokes to represent groups of leaves gently moving in the breeze. The impression of reeds in the fields and foreground were painted with almost vertical brush strokes which also suggest the lack of wind. If it had been windy, these and the willow trees would have been leaning dramatically against the wind and I would have automatically painted them that way. Remember, observe and paint what you see, but exaggerate nature to help your painting, and you will capture the atmospheric conditions of the day, however subtle.

▲ THE OLD WINDMILL, POTTER HEIGHAM
Watercolour on cartridge paper
20 × 28 cm (8 × 11 in)

*This painting conveys the atmosphere of a warm, sunny day. Over the page, I have painted the same scene in early morning and late evening to show it in two different moods.*

I chose the scene for my watercolour painting on the previous page so that, if the weather conditions were right on another day, I could be on the spot at a moment's notice to paint the same view with a more dramatic atmosphere, this time using oil colours.

One evening when we arrived back at our Norfolk cabin from a painting expedition, the conditions were perfect. The sun was going down over the trees and casting a yellowy-orange glow over the whole landscape. Actually, by the time I was ready to start, I had already lost 15 minutes, tripping over myself with excitement (less haste, more speed!).

I had about 25 minutes left before the sun would disappear. There wasn't time to draw the scene, so I started painting straightaway. I began with the mill, then put in the silhouetted trees on either side of it and the foreground fields.

Next I painted in the sun and worked into the sky. Incidentally, only look directly at the sun a few times because it has a dazzling effect, making green and red blobs appear in front of your eyes when you look back at your work, slowing down your painting time. I used only three brushes: a No. 8 Cryla brush, a No. 2 bristle and a No. 6 sable brush to suggest the reeds and the tree branches.

Notice how I closed-up on the scene more than I did in my watercolour on the previous page. This wasn't intentional and I didn't realize I had done so until I put the paintings side by side.

▼ SUNSET AT POTTER HEIGHAM
Oil on primed Waterford paper with acrylic Raw Sienna wash
25 × 30 cm (10 × 12 in)

*You don't get very long to paint a sunset when the sun is as low as this. Choose a simple landscape rather than a complicated one and have your materials organized so that you are ready to start the moment the sun is in the best position for your painting.*

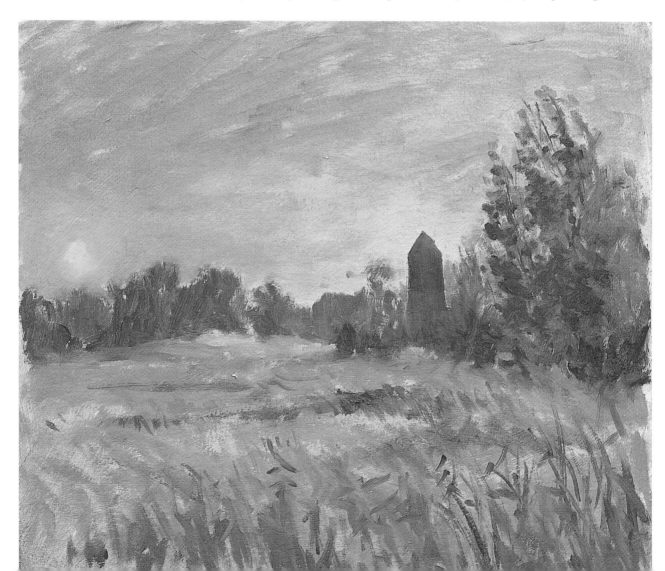

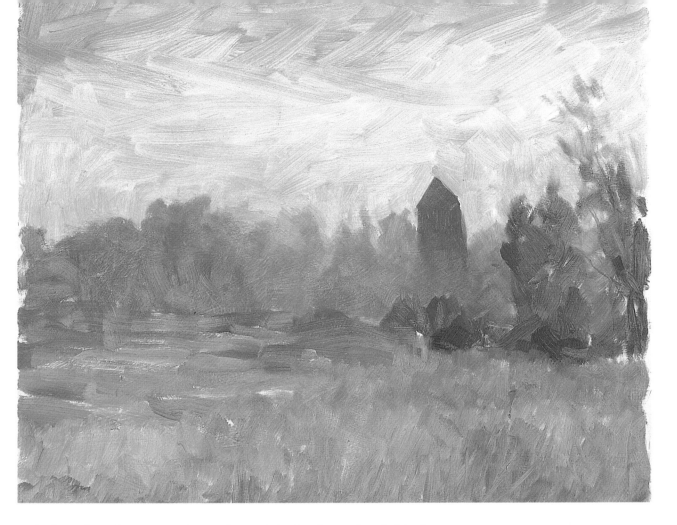

A few days later, we planned to visit the lavender fields in Norfolk to do some painting. That morning, the alarm went off and I got up and started to make a cup of tea. Then June called out that it was only half-past five! It was my own fault – I'd set the alarm incorrectly. I still felt tired but I drew the curtains back and looked outside. Suddenly I was wide awake again! There was the same scene, but this time with a mist rolling over the river and marshes. I couldn't miss this. I got my oil paints ready and, within ten minutes, I was sitting outside, in the same spot from which I had painted the sunset a few nights before.

## A COMPLETELY DIFFERENT MOOD

It looked so different and, because of the mist, the scene appeared cold. The windmill was very prominent but the trees and fields kept disappearing and reappearing as the mist swirled around. In fact, I was so involved in observing the scene that I didn't start painting for another ten minutes.

As with my evening painting (left), I didn't draw the scene but went straight in with my colours. I painted thinly at first (with plenty of turps) starting with the mill and the surrounding trees and working down the fields. Then, using a lot of white paint mixed with the field colours on the palette, I painted the sky.

When I saw the last two paintings together, I was surprised at how much larger I had painted the mill in the misty painting. I can only assume that it was because the mill was the only strong and prominent shape I could see through the mist.

▲ EARLY MORNING MIST, POTTER HEIGHAM
Oil on primed hardboard
25 × 30 cm (10 × 12 in)

*In this painting I went over the distant trees very delicately with the sky colour to give the impression of mist. Because the trees were still wet, the paint mixed with some of their colour and this also helped to create the illusion.*

## TIRED BUT INSPIRED...

When you have been out for hours, driving and walking while looking for scenes and then, of course, painting them, you feel fulfilled but totally exhausted. Yet it is amazing how we can all find extra energy when we are inspired. This is what happened to June when she saw the sunset (below). We stopped the car and she quickly set to work. As usual, time was at a premium but, because we had been working all day, June wasn't starting 'cold' and was soon enjoying her painting.

She did very little drawing, then started by laying a wash of Cadmium Yellow Pale and Crimson Alizarin for the sunlit areas in the sky, adding French Ultramarine and Hooker's Green No. 1 to the colour as she worked down to the foreground. When this was dry (she dried it by the car heater for speed), June worked over the top with darker colours, leaving the sunlit area of sky.

When this was dry, she painted another dark tone mixed from French Ultramarine, Crimson Alizarin and a touch of Yellow Ochre over the distant hills and, using the same colour, suggested hedges and stone walls. Finally she mixed a warmer colour, using Hooker's Green No. 1 with Crimson Alizarin and added dark areas to the foreground.

It took June 40 minutes to capture the atmosphere of the end of a winter's day on the moors. Then she really did feel tired!

▼ SUNSET OVER DARTMOOR
Watercolour on Bockingford paper
20 × 28 cm (8 × 11 in)

*June painted this sunset at the end of a long day of painting on Dartmoor.*

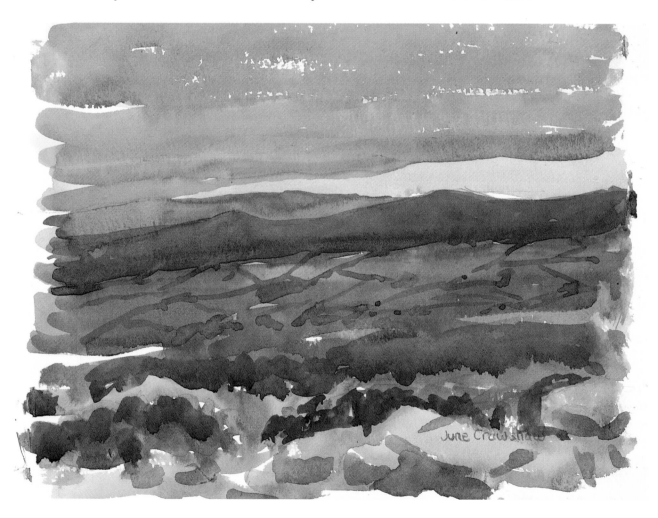

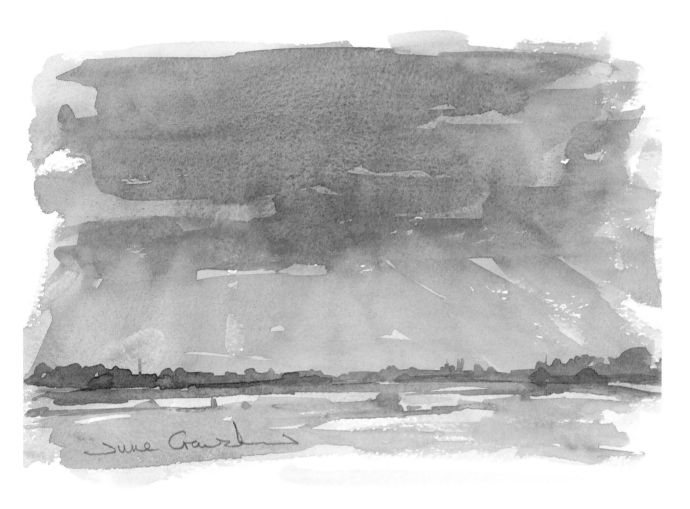

June's painting (above) is a much subtler sunset than the one shown opposite. Whenever you encounter a very cloudy and rainy sky, practise sketching an atmospheric scene like this because it will give you invaluable experience for when you work back at home.

In fact, why don't you go out for the day with the intention of painting for atmosphere only? Apart from the pleasure it will bring, you will learn a tremendous amount. Don't try for detail – that is not the object. Pick a simple scene with very little drawing.

## PRACTISE SKETCHING THE SKY

You will find that the sky usually plays the most important part in your painting. You should also sketch some sky studies because the sky in a landscape sets the scene for your painting. By looking at the sky you can tell if it is sunny, rainy, windy, misty, evening or morning, etc., and these conditions can be reflected through your paintings to give them atmosphere.

After you have gained some experience of painting atmosphere, don't be afraid to exaggerate different effects to make your picture work better. However, do remember that, with the majority of atmospheric conditions, you will often only have time to do a sketch. Unfortunately, we weren't able to take photographs of the scenes for the last four paintings. In those lighting conditions, our photographic knowledge wasn't sufficient and anyway it would have taken up valuable painting time!

▲ SHOWERS STILL AROUND, NORFOLK
Watercolour on Bockingford 200 lb paper
18 × 25 cm (7 × 10 in)

*Cloudy or rainy days like this provide wonderful opportunities to work on sketches with plenty of atmosphere.*

## FROM JUNE'S SKETCHBOOKS

The pencil is a wonderful medium to use when you are travelling. It can be used anywhere without preparation or clearing up. However, do remember to carry an eraser with you – it is just as important as your pencil. There are times when you will have drawn something totally out of position or scale and the only answer is to rub it out to correct it. An eraser is not just for learners or the faint-hearted, it is a very important tool for the artist.

June's sketch (top left) is of Willy Lott's Cottage on the River Stour, made famous by the artist John Constable in the 18th century. If you wanted to work at home from a sketch like this (which gave June enjoyment and a feel for the subject but no detailed information) you would need to take a photograph for reference. This applies to all pencil sketches unless they are of uncomplicated scenes, or subjects with which you are already familiar.

A sketch can teach you to draw, to observe and to gather information. Sometimes it is a creative piece of art in its own right. At other times, sketches make good starting points at home for larger, more studied paintings.

Most importantly, sketching should be enjoyable. It is a wonderful way of working outdoors with nature and experiencing the thrill of being creative.

These sketches of June's were drawn approximately one-third larger than they are reproduced here.

# PAINTING TREES

Trees have always been one of my favourite painting subjects. I'm not sure whether it is because they play a very important part in a landscape painting, or because they need less accurate drawing than some other subjects! Whatever it is, they really get my artistic juices flowing! June has always loved trees but over recent years has painted them more. Nowadays, a walk in the countryside is exciting and artistically rewarding for both of us!

## LEARN BY OBSERVATION

It's amazing how much you can learn about trees by walking among them and observing. Concentrate on two or three types of tree to begin with and start by drawing trees without leaves as this helps you to understand important aspects, such as how branches grow from the trunk and how the trunk grows out of the ground.

When we were in the Dordogne, I painted the picture (below). The two trees in the distance are suggested by their overall shape – there is no detail. The nearer trees on the left have more suggestion of leaves – these were worked with short, open brush strokes. Lack of detail on the distant ones keeps them from jumping to the front.

The painting (above right) shows how I tackled a small tree, close-up. I put in the leaves with my No. 6 sable brush, watery paint and 'blobby' brush strokes. When they were dry, I painted darker ones over them, and when those were dry, I painted ones that were darker still. These different tones help to give the tree dimension.

When June saw the orchard of pink blossoms (below right) on our trip to Brittany she just had to paint it.

◀ LA ROQUE-GAGEAC, DORDOGNE, FRANCE
Watercolour on cartridge paper
28 × 40 cm (11 × 16 in)

*The trees on the left-hand side of the picture were painted with my No. 6 sable brush. I started at the top and worked down, changing the colours as I worked but allowing them to mix together. Notice how I left some white paper unpainted. This helped to give movement in the trees.*

48

◄ FROM BEYNAC CASTLE,
DORDOGNE, FRANCE
Watercolour on cartridge paper
28 × 20 cm (11 × 8 in)

*Because the tree is in the
foreground and an important part
of the painting, I put more detail
into it. I took the photograph
(above) as soon as I started to
work. When I had done the
drawing and started to paint, a
damp mist came down. Twenty-
five minutes later it was starting
to rain but I had just finished!*

◄ BLOSSOM, BRITTANY, FRANCE
Watercolour on cartridge paper
20 × 28 cm (8 × 11 in)

*June captured the shapes and
colours of this small orchard
perfectly. The pink blossom
contrasts well with the greens of
the other trees, and the round
shapes of the trees look good
with the tall foreground grasses.
She added some very dark areas
on the background trees against
the blossom to help show shape.
I didn't do so well with my
photograph of the scene, which
was far too dark to reproduce!*

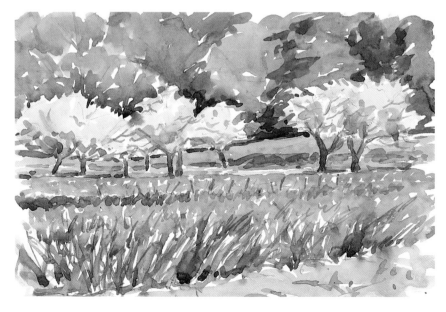

This painting of the woods was done on the same day that we went to paint bluebells but found they weren't in bloom. We decided to concentrate on trees instead and this scene certainly took our minds off bluebells!

We both felt that this mass of trees was a real challenge. The most important thing to decide was which features could be found and used. Always try to simplify a scene as you look at it – in a situation like this, ten minutes of careful observation is invaluable.

June decided that the path was important because it lead you through the woods. She also decided which trees to make prominent and that she would paint the picture portrait-shape. All these decisions seem simple and obvious but they were the result of serious consideration. Unless you actually sit and calmly look at what is in front of you with a scene like this, you will not be able to cope with it.

## FIRST STAGE
June drew in the path first, then established the main trees with a 2B pencil. She painted in the sky behind the trees using French Ultramarine and Crimson Alizarin but added a little Cadmium Yellow Pale and Hooker's Green No. 1 for the

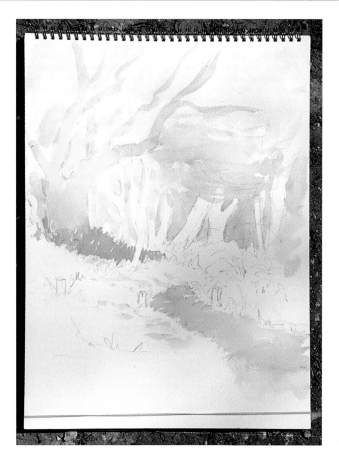

◄ FIRST STAGE

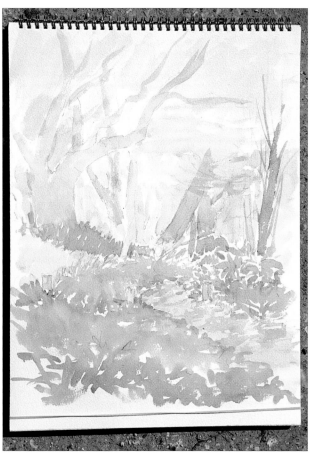

◄ SECOND STAGE

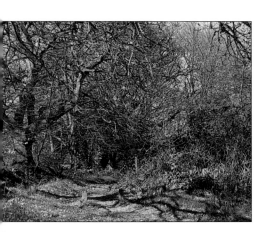

bright green areas. She then added French Ultramarine to the mix for the dark green area under the main tree. The path was then painted in, using a mix of Yellow Ochre and Crimson Alizarin.

### SECOND STAGE
When this was dry, June worked on the trees using her No. 6 sable brush. She then painted in the foreground with her No. 10 brush.

### FINISHED STAGE
Next June painted the shadows on the grass and path and then worked on the trees again. It is impossible to reproduce the complex tracery of branches exactly. Just paint in what you believe is enough for your painting. Finally, using a mix of French Ultramarine and Crimson Alizarin and a dry brush technique, June painted behind the trees to create a feeling of distance.

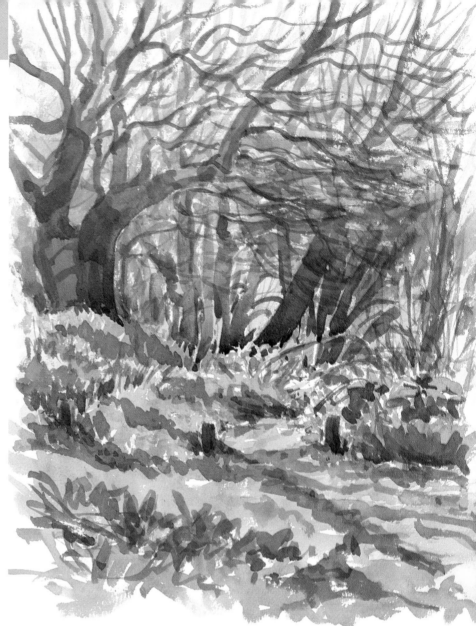

▶ EAST HILL WOODS
Watercolour on Bockingford
140 lb paper
38 × 30 cm (15 × 12 in)

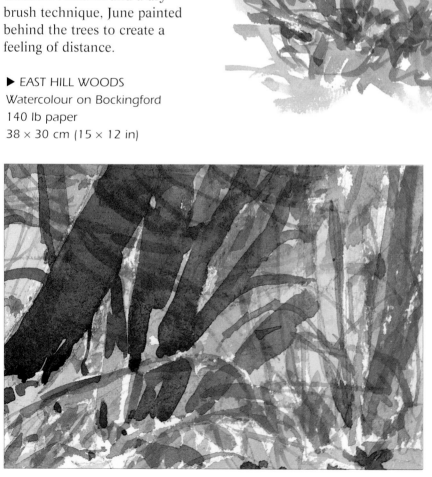

◀ *In this close-up detail, you can see that June left plenty of bright or light-coloured areas showing after she had painted the shadows. This helped to give the illusion of sunlight dancing through the trees.*

Here I painted the same scene as June did for her demonstration on the previous page. I was sitting some way to her left and from my different viewpoint I could just see a gap in the distance as the path went through the trees. I omitted some brambles in the foreground and painted the opening, and this helped my composition a lot.

## FIRST STAGE

I had previously put a wash of acrylic Ultramarine and Crimson over the canvas. Now, using a No. 6 sable brush and a turpsy mix of Cobalt and Crimson Alizarin, I drew in the main trees, the paths and the distant hills and fields.

## SECOND STAGE

Still using thin turpsy paint but this time with my No. 4 bristle brush, I scumbled in the warm colour at the top of the trees and then worked down behind them. I used a mix of Cadmium Yellow and Crimson Alizarin and added a little Cobalt Blue for the darker areas of the distant fields. Because the colour with which I had drawn the scene was still wet, it mixed with my new colours and helped to soften the drawing. I

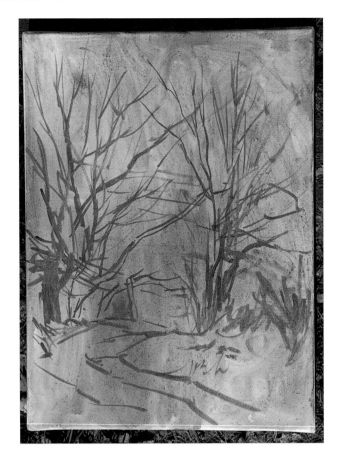

◄ FIRST STAGE

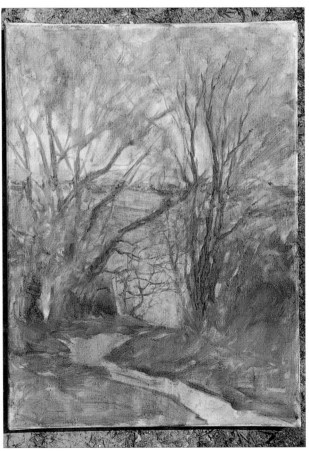

◄ SECOND STAGE

then painted the foreground grass and, with my 'Rigger' brush, painted some small branches over the opening through the trees.

## FINISHED STAGE

Still using thin paint and my No. 6 sable and 'Rigger' brushes, I painted most of the branches on the trees. Then, using thicker opaque paint, I painted the sky and the distant hills and fields between the branches. Don't try to do this too precisely or you will lose the feeling of movement and life in the trees. You will also be there all day! For this I used my No. 2 bristle brush.

I then painted thicker paint on the foreground. I had now been working for three hours and this was a perfect time to stop and have a picnic lunch. After lunch, I saw the painting with a fresh eye and carefully painted some more branches, made the shadows stronger on the ground and, finally, made the hole in the trees at the end of the path even lighter.

When I looked at it back home, I was surprised at how dark the painting was and how much work I had put into the branches. June's watercolour and my oil painting certainly demonstrate the difference between the two mediums!

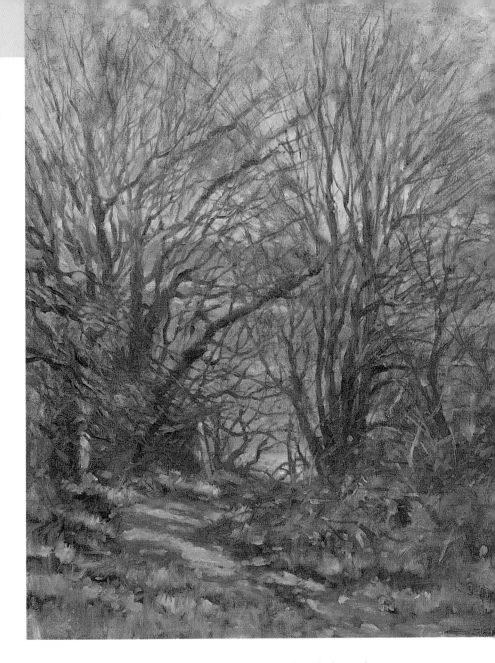

▲ EAST HILL WOODS
Oil on canvas with an acrylic wash of Ultramarine and Crimson
40 × 30 cm (16 × 12 in)

▼ *This detail shows how I painted in-between some of the branches to show the landscape that I could see behind them.*

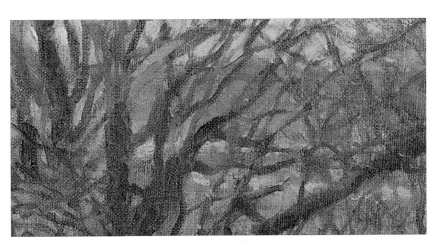

On our 'bluebell painting day', June eventually succeeded in finding a view she wanted to paint, without other artists blocking her view!

## FIRST STAGE

She drew the trees first with a 2B pencil and then positioned the path. The trees were painted with a mix of Yellow Ochre, Crimson Alizarin and a touch of French Ultramarine, and she put in a suggestion of the path with the same colour.

◄ FIRST STAGE

## SECOND STAGE

When this was dry, June painted a wash of Cadmium Yellow Pale mixed with a little Hooker's Green No. 1 between the trees. This was to convey the mass of leaves and the wash was continued on the ground under the trees, for the grass. French Ultramarine was added and painted on the right-hand tree to suggest ivy. Some green areas were painted in the foreground for grass and bluebell leaves.

## THIRD STAGE

The bluebells were painted next with a varying mix of French Ultramarine and Crimson Alizarin. June used a No. 6 sable brush and worked with up-and-down brush strokes. She left some white paper unpainted and added some more green while the painting was still wet.

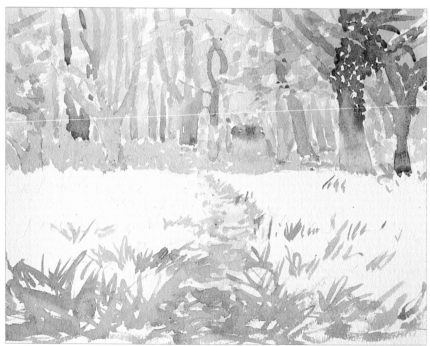

▲ SECOND STAGE

▼ THIRD STAGE

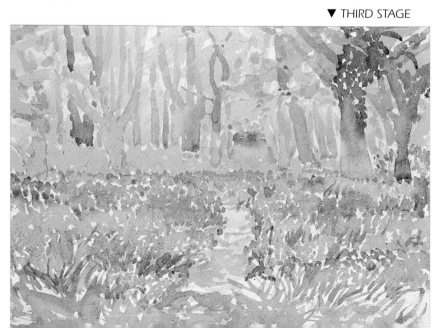

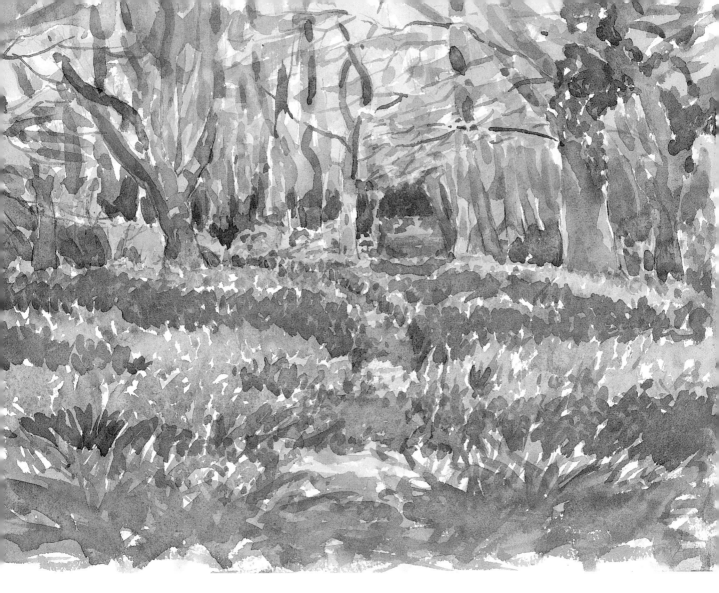

## FINISHED STAGE

When this was dry, she used a stronger 'bluebell colour' and painted shadows over the bluebells and the path. Darker areas were painted at the base of the distant trees, and some of the trees were made darker and more branches were added.

June really enjoyed painting this scene and felt it had a fairy-tale quality. At one point, I left the painting I was working on to see how she was doing. While I was standing beside her looking at the view, a deer walked across the scene but, unfortunately, I was too late with the camera!

▲ THE BLUEBELL WOOD
Watercolour on Bockingford
250 lb paper
28 × 38 cm (11 × 15 in)

▼ *June was lucky to find a painting scene that wasn't full of people. There seemed to be almost as many artists as bluebells in the wood!*

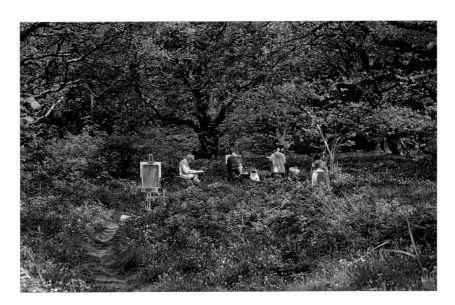

# CHOOSING DRAMATIC SUBJECTS

What makes a dramatic painting? Some scenes are naturally full of drama because they are action-packed, such as a lifeboat tossing on a rough sea or horses galloping in a race. However, you can also find drama in a quiet landscape or townscape. Painting dark-against-light can give a very dramatic effect to a painting. Imagine that you were looking down a narrow street where all the buildings near to you were in shade. If the buildings at the end of the street were bathed in strong sunlight, the 'tunnel effect' leading to brightness would be very striking.

## ADDING EXCITEMENT TO SCENES

Exaggerated perspective, or painting a scene from an odd angle, can also be a powerful tool. However, you need to do this carefully, or your scene could look badly drawn. With experience, you will find many ways of adding excitement to fairly ordinary scenes when you are working outdoors. I am sure you can think of many more

▼ *In this first stage, June started with very pale colours. The distant trees were kept cool, to portray distance, and the nearer trees were worked in warmer colours. Notice how simply the trees are suggested.*

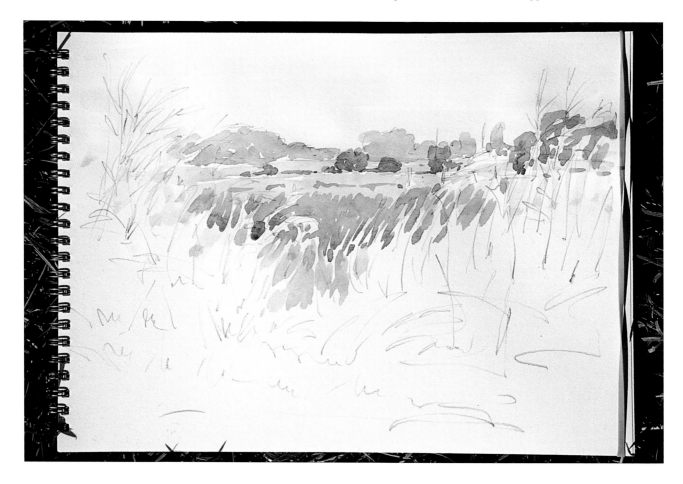

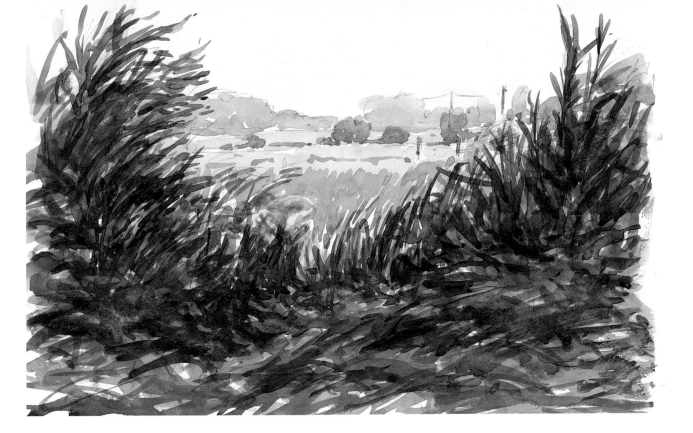

examples. One thing is certain, a dramatic composition usually stands out in a crowd and, in the end, like beauty, drama is in the eye of the beholder. So if you paint a very dramatic scene, it may not be everybody's cup of tea!

One day, when June and I were looking for subjects to paint on a hot afternoon in Norfolk, the sun was high and the landscape looked flat and bleached out. We also needed some shade to work in. After walking for a while, we finally found some trees that gave us this and, most importantly, a view to paint. The only way to tackle the flat, featureless landscape was to use the trees as silhouetted shapes in the foreground, dark-against-light. This would also help to give the impression of bright sunlight.

I used the trees in this way for a small oil painting but it was a flop and I didn't like it. I blamed the heat! But June did the effective and dramatic painting (above). She had found a ditch with tall reeds and rushes growing from its sides. The nearby trees were casting strong shadows and there was a natural break in the rushes, so June painted the landscape which was visible through this. The reeds were painted very dark and these flank the light area of the landscape. This contrast gives the illusion of bright sunlight and makes for a dramatic composition.

▲ SUNLIGHT ON THE MARSHES, NORFOLK
Watercolour on cartridge paper
20 × 28 cm (8 × 11 in)

*June painted the reeds very dark to contrast with the distance, which was sunlit. She made a point of working the brush strokes freely but in a controlled pattern. This stopped the dark area of reeds from looking flat and uninteresting.*

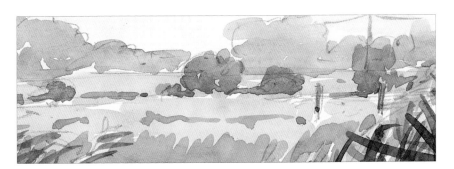

◀ *This close-up shows how simple brush strokes can create distance. No detail was needed.*

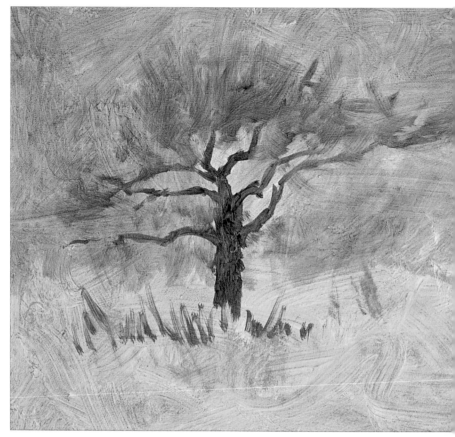

▲ FIRST STAGE

While June was painting the trees in blossom on page 49, I decided to paint a single tree close-up. I found one that was fairly isolated and looked at it from different angles, eventually deciding to paint it from a low viewpoint to get a little drama into the painting. Time spent looking at different aspects of a scene to get the best painting situation is very worthwhile. But don't overdo it or you won't have time to do your painting!

From the view I had chosen, there was another tree behind and to the right of my subject. This wouldn't have helped the composition, so I left it out.

## FIRST STAGE

I had previously put an acrylic wash of Raw Sienna on the primed hardboard. I started by painting a thin turpsy wash of Cobalt Blue and Crimson Alizarin over the sky area. Then, using a No. 6 sable brush, I drew in the tree with a mix of Cobalt, Viridian and a touch of Crimson Alizarin. I used a No. 4 bristle brush to scumble in the area of leaves over the branches.

## SECOND STAGE

I painted in the house and distant trees using Cobalt Blue and Crimson Alizarin and adding Titanium White to these colours. I did the underpainting for the grass very freely using a turpsy mix of warm greens. I also added more branches to the tree.

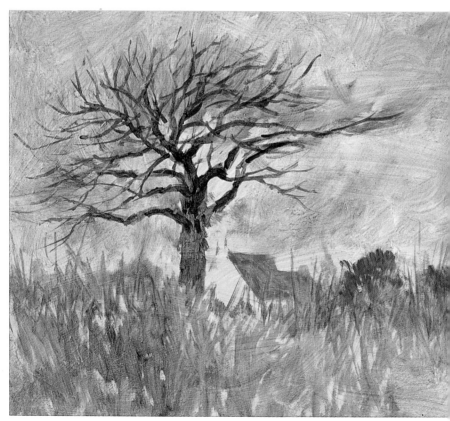

▲ SECOND STAGE

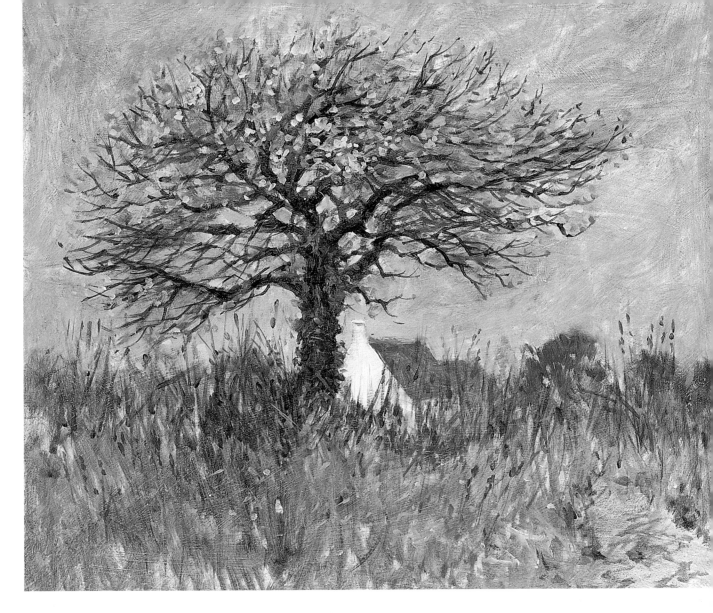

## FINISHED STAGE

Using the tree colours opaquely, I painted more branches and suggested ivy growing on the trunk. I then used thick paint to work the sky around the tree, painting small areas between the tree branches. Notice how I painted the sky lighter nearer the horizon. The blossom was achieved with a No. 2 bristle brush and a mix of Titanium White and Crimson Alizarin by 'blobbing' thick paint on to the existing tree.

Finally, with a No. 6 sable brush, I painted some detail in the grass.

▲ TREE IN BLOSSOM, BRITTANY
Oil on primed hardboard with an acrylic wash of Raw Sienna
25 × 30 cm (10 × 12 in)

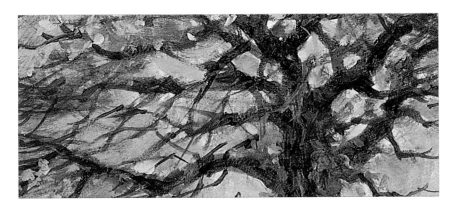

◄ *Some of these branches were the ones I originally drew in, others have been added later. Notice how the sky has been painted in-between the branches in places. I love this part of painting trees!*

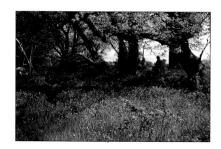

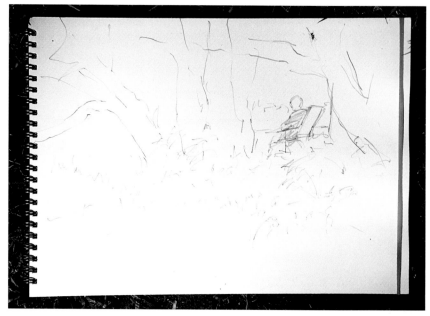

▲ FIRST STAGE

On our memorable bluebell painting day, June was determined to paint another picture while the bluebells were still in bloom to make up for our disappointing trip two weeks earlier. It's a good job we took a picnic with us this time!

She spotted one of the artists from the local art class working silhouetted against the sky and was immediately inspired. The trees and the figure were very dark against the background and added drama, while the bluebells brought colour and movement to the scene.

## FIRST STAGE

June started by drawing the artist in position on her sketchpad and then established the trees around the figure. This was done with a 2B pencil.

## SECOND STAGE

She painted the sky first using a mix of very pale French Ultramarine, Crimson Alizarin

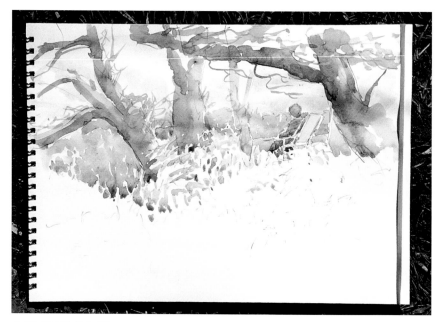

▲ SECOND STAGE

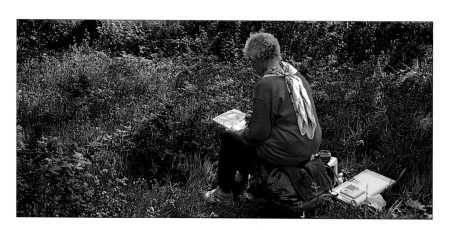

◀ *June among the bluebells. Because our car (acting as base camp) was parked nearby, June had a stool and used a small table for her paints and water jar. She also had different-sized pads and a board for working on. It is sheer luxury when you can have all this equipment with you.*

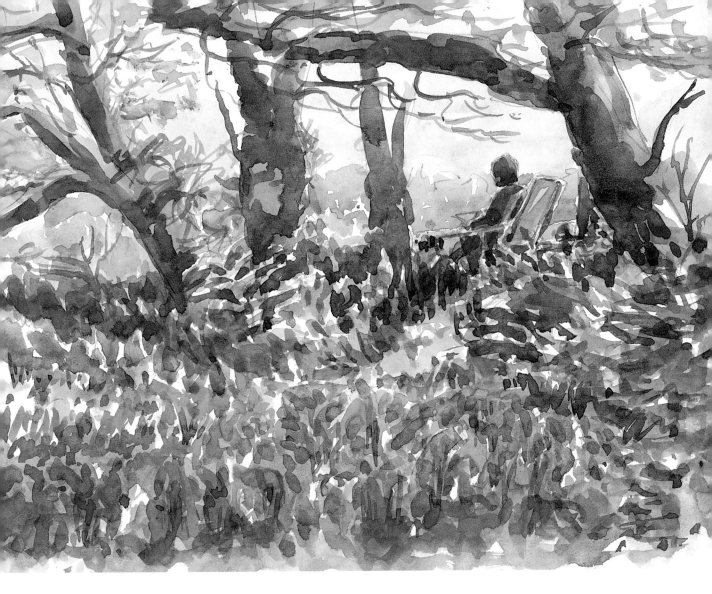

and, near the horizon, a little Yellow Ochre. While this was wet, she added Hooker's Green No. 1 and painted the distant trees. June kept this part of the painting pale to contrast with the silhouette.

When this was dry, June painted the trees with a watery mix of Yellow Ochre, Crimson Alizarin, Hooker's Green No. 1, with a little French Ultramarine for the darker areas. Some green was added in places to represent foliage. Then using French Ultramarine and Crimson Alizarin, she started painting the bluebells.

## FINISHED STAGE

June continued painting the bluebells, working down the paper. As in her previous bluebell painting, she left some flecks of unpainted white paper as she worked, which helped to give light and movement. Different tones of green were also worked in to represent leaves and grass.

When this was dry, she mixed French Ultramarine, Crimson Alizarin and a little Yellow Ochre to paint shadows over the trees and bluebells but left unpainted areas on both the trees and the bluebells to represent sunlight.

June was concerned that she had painted the shadows too dark but felt that they would dry lighter. She breathed a sigh of relief when they did – haven't we all had that experience?!

▲ ARTIST AMONG THE BLUEBELLS
Watercolour on cartridge paper
20 × 28 cm (8 × 11 in)

# PAINTING OPEN SPACES

Most of us have a natural or favourite type of scene that we like to paint. Mine is open spaces and I become tremendously inspired when looking over miles of landscape under a vast expanse of sky. It makes me feel alive and I just have to paint it.

June's favourite subject is a closer, more intimate scene. She loves walking through woods, especially ones covered with bluebells! Fortunately, we are equally happy painting each other's favourite subjects – or we would never paint together! However, sometimes we get the best of both worlds. When I went off to paint the distant view from the top of the sand dunes on page 17, I left June happily painting a close-up of the breaking waves on the beach.

## CHOOSING A POINT OF INTEREST

To make an 'open space' painting work, you must have some feature for your point of interest, or your painting could look flat and uninteresting. This might be a distant town, a mountain, a group of trees or a herd of cows. Or you could make the point of interest your colours, or tonal contrast (dark-against-light), as in a dark, stormy sky with bright, sunlit fields emphasized by deep shadows on the rest of the landscape. As I have said before, don't be afraid to exaggerate a feature to help your painting.

On one of our favourite walks in Norfolk, we have to negotiate a very rough and usually muddy path through a tunnel of overhanging small trees and bushes. If we look to the right, through the trees, we can see the boatyard at Potter Heigham. I had wanted to paint this scene ever since I first saw it and, one afternoon, we set off through the tunnel of trees. To be able to see the boatyard, I

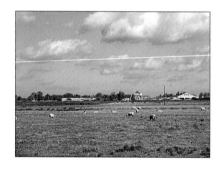

▼ *In this close-up detail, you can see the tonal shading I did on the side of the sheds and the trees with my pencil . But notice how freely the watercolour was painted over this, stopping the distance from jumping forward.*

had to work standing up on some very slippery, uneven ground, looking through the trees. June had sensibly gone further down the path and was sitting comfortably on her seat sketching sheep!

I was using my A3 sketchpad and, although I was resting it on my Travelling Watercolour Studio as I stood and painted, I soon found that my arm and back were both aching. I often stress the importance of being comfortable when you are working but there are always exceptions to the rule and this was one. It didn't help that I had misjudged an overhanging branch when we negotiated the tunnel of trees and could still feel the bump on my head!

A drainage ditch cut across the field a little way to the side of my scene but, although I tried to see the boatyard with the ditch in the picture, the trees were in the way. So I moved the ditch into my painting. I did this to help break up the field in the foreground. It also leads you into the picture to the tall building in the boatyard. After all the effort, I was very happy with this painting.

▲ BOATYARD, POTTER HEIGHAM
Watercolour on cartridge paper
28 × 40 cm (11 × 16 in)

*Although I was very uncomfortable when I painted this scene, I thoroughly enjoyed doing it!*

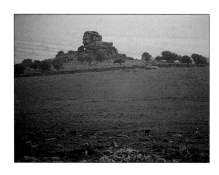

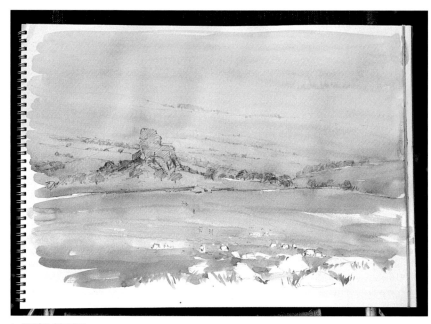

▲ FIRST STAGE

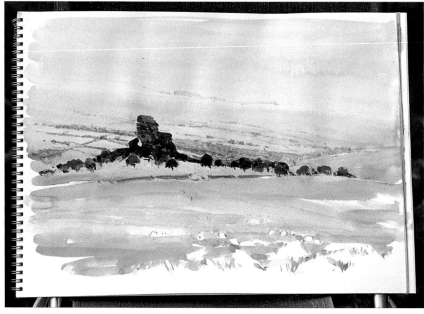

▲ SECOND STAGE

When June and I are travelling by car, we always pack rainwear, some warm clothing, a flask of hot tea or coffee, different-sized sketchbooks – in fact, anything we think we might need to make painting more comfortable. Of course, once we leave the car to walk to our painting spot, we only take the minimum we require and use the car as a base camp.

When I did the painting of Vixen Tor (opposite), we had left Dawlish in the morning when the sun was out and it was warm. I started painting the scene in the early afternoon and suddenly one of Dartmoor's famous mists developed and it became very cold. However, the car was only a little way away and a warm sweater, a coat and a hot cup of tea from our flask made the rest of this atmospheric painting possible.

## FIRST STAGE

I drew the picture first and put in some tonal shading with my 2B pencil. At this stage, the mist was covering the distant hills and was creeping closer.

I painted a wash of various colours from the top to the bottom of the picture, allowing the different colours to merge together. I used French Ultramarine with Crimson Alizarin at the top, then added Yellow Ochre and more French Ultramarine behind the tor.

Notice that I actually painted over the tor. Then I used Hooker's Green No. 1 and Yellow Ochre for the foreground field. I did all this with my No. 10 sable brush.

## SECOND STAGE

When this was dry, I suggested some distant trees and hedges. Then I painted the tor and the small trees in front of it.

64

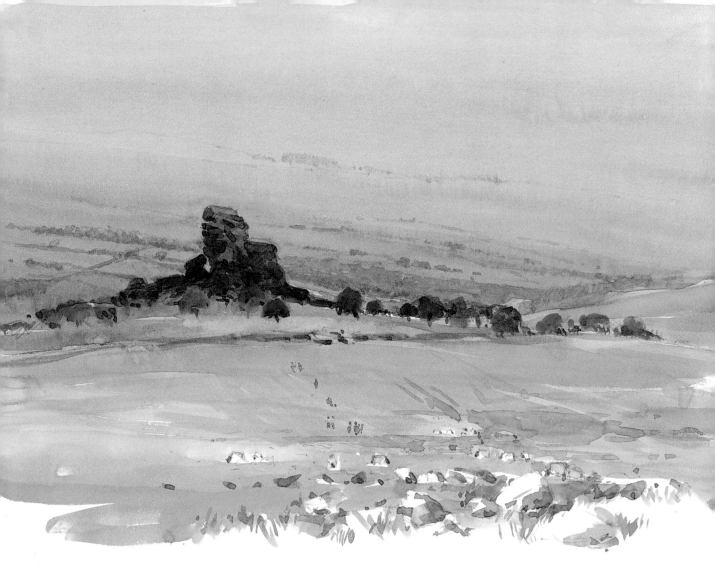

## FINISHED STAGE

By now, the mist had become more dense, so I made the decision to put another wash over the sky and landscape to capture the effect. It wasn't an easy decision – if it didn't work, this could ruin the painting!

I started at the top with a mix of French Ultramarine and Crimson Alizarin but added more blue as I worked down behind the tor and the small trees. I continued over the field on the left and beneath the tor.

Finally, I suggested people in the field and put some modelling into the foreground rocks and grass. Notice how the foreground is warm but the distant fields are cool in colour, giving the illusion of distance.

▲ VIXEN TOR, DARTMOOR
Watercolour on cartridge paper
28 × 40 cm (11 × 16 in)

◄ *The tor was painted dark but I left some light areas on it to show form. The dark colours contrast against the background and push it back, giving an impression of space and distance.*

65

While we were in Ireland making our television series *Crawshaw Paints Acrylics*, June and I unexpectedly found ourselves with most of one day free. We set off looking for a place to paint, just for the sheer enjoyment of it, and came across this breathtaking view near Portmagee – certainly a wide open space!

Having found a convenient wall to sit on which overlooked the view, we both set to work.

## FIRST STAGE

I started drawing in the distant shoreline, the fields and the mountains. The mud areas and seagulls were drawn in carefully as these helped to show scale.

Because clouds were moving across the sky, the mountains often went into deep shadow while we were there and I decided to paint them this way.

## SECOND STAGE

I painted the sky freely and then worked down over the mountains. When this was dry, I put a dark wash mixed from French Ultramarine, Crimson Alizarin and a touch of Yellow Ochre over the mountains.

Then I painted the green fields and, finally, the water. When the mountains were dry, I painted another dark wash on them to add dimension.

## FINISHED STAGE

Finally, I added more dark 'blue' to the base of the mountains on the right, suggested trees and buildings and painted the mud areas in the foreground, making sure I left some unpainted white paper to represent birds.

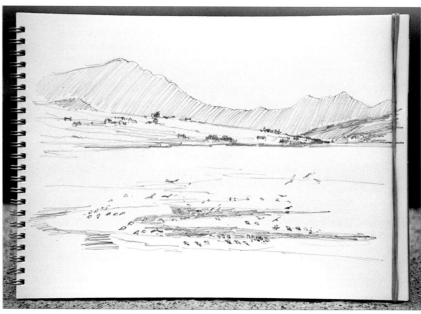

▲ FIRST STAGE

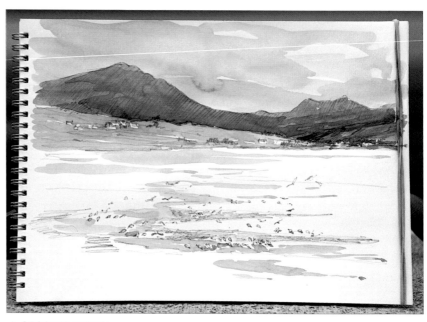

▲ SECOND STAGE

◀ *June took this photograph of me while I was busy painting for this demonstration. Weren't we lucky to find this wall to sit on!*

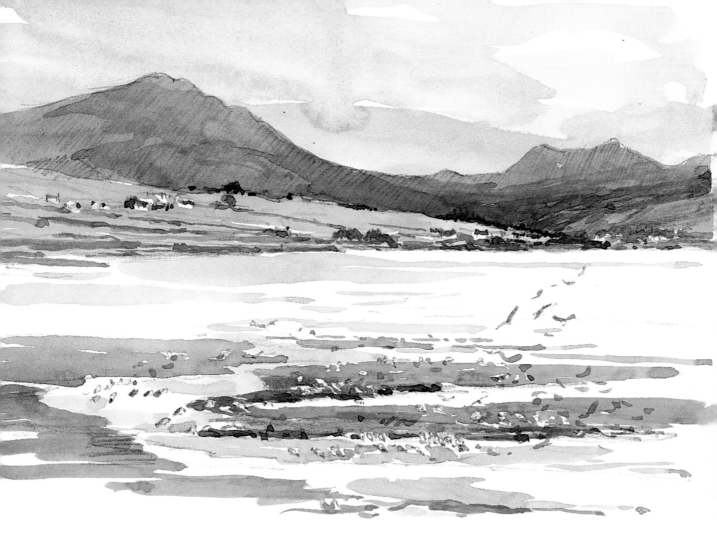

▲ NEAR PORTMAGEE, KERRY,
IRELAND
Watercolour on cartridge paper
20 × 28 cm (8 × 11 in)

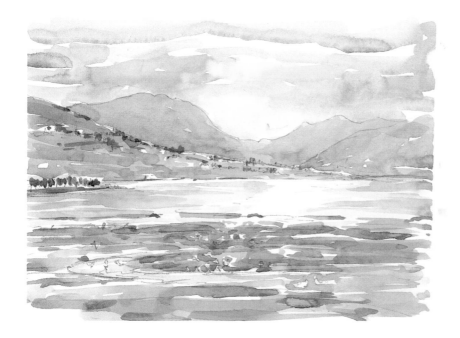

◀ NEAR PORTMAGEE, KERRY
Watercolour on cartridge paper
20 × 28 cm (8 × 11 in)

*June decided against painting the
mountains in shadow and her
ones are much paler than mine.
She captured a wonderful light in
the trough of the mountains and
this is reflected in the water to give
a mellow, mysterious look. The
seagulls didn't play an important
part because they could have
detracted from the light on the
water. June condensed the distance
between her mountains (perhaps
because she likes more intimate
subjects?). I expanded it in mine.*

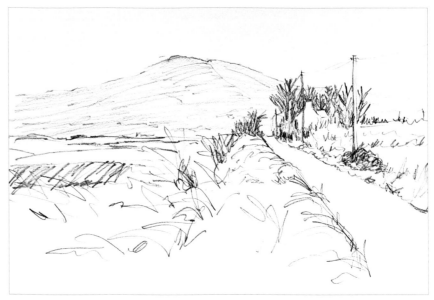

▲ FIRST STAGE

After painting the mountains near Portmagee (shown on pages 66–7), we were heading back to our base at Parknasilla, when June spotted this white cottage silhouetted against the dark trees and the mountains behind it. Luckily, we had taken our usual flask of tea with us – in a spot like this, there wasn't a teashop for miles! After a refreshing cuppa, we were ready to tackle anything!

The flat area to the left of the road stretched for miles and peat digging had left very pronounced patterns in the fields. (In fact, you can see a small pile of peat on the right-hand side of the photograph.)

While June was working on this painting, I decided to paint the fields but was rather disappointed with my painting. You must be prepared for results that don't quite come up to your expectations – we all get paintings like this. The answer is to do another one as quickly as possible. It's a bit like falling off a bike – you must get back on again quickly! I did another painting later that afternoon and was very happy with it.

## FIRST STAGE

June was bold with her drawing. She also shaded in the tonal areas as she drew.

June really enjoyed doing this because she was inspired by the scene. This will always get the best work out of you.

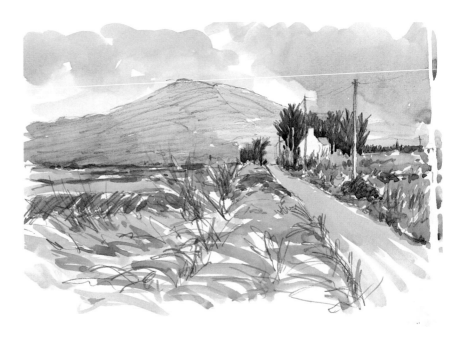

## FINISHED STAGE

June was just as free with her brush strokes but took care around the cottage. The dark trees were also put in carefully, leaving white unpainted paper for the cottage. Another important feature was the road, which leads us to the cottage and into the painting. The cool blue of the mountain contrasts perfectly with the warm colour of the fields and foreground, adding space and distance.

▲ BY THE PEAT FIELDS, KERRY
Watercolour on cartridge paper
20 × 28 cm (8 × 11 in)

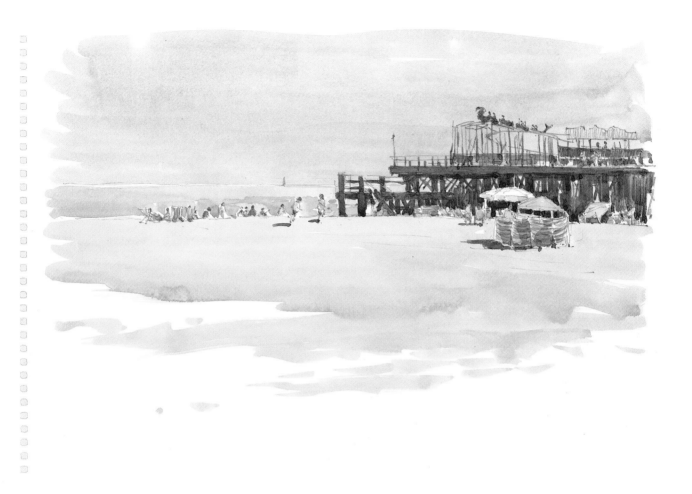

When June was painting her more intimate scene of the beach at Great Yarmouth on page 25, I was busy painting the distant view of the pier (above) with its fairly empty expanse of beach.

I drew the horizon in first and next the line of the beach. I was then able to determine the size of the pier, which I drew reasonably carefully. Finally, I drew in the people on the beach.

I painted the sky, the sea and then the pier, leaving white unpainted paper for the people and sun umbrellas. Next, I painted the beach and you will see that I didn't put any modelling into it. If I had, the shapes and tones might have distracted from the people on the beach and spoilt the simplicity of the painting. This also helped to give the impression of open space. Lastly, I painted in the people, the umbrellas and the windbreaks.

▲ THE PIER, GREAT YARMOUTH
Watercolour on cartridge paper
28 × 40 cm (11 × 16 in)

*I kept this painting simple so that the eye isn't distracted from the wide expanse of sand.*

◀ *The beach at Great Yarmouth.*

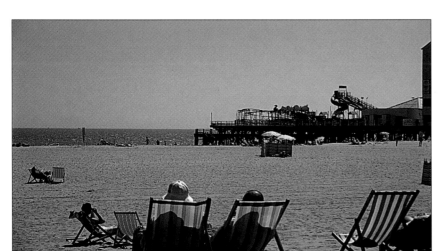

# PAINTING
# WATER

Water has many visual moods – it can change as quickly as the sky. As with every aspect of nature, it is important to study and observe it in its different moods. Even if you don't paint while you are travelling, remember to look at things with a painter's eye. Imagine you are going to paint the scene or subject and think about how you would achieve it. I am lucky, I was told to do this back at art school and have had many years of looking and observing how to translate nature on to paper.

I am a great believer that when you are painting water, you shouldn't overwork it. You can usually give a better illusion of water by keeping things simple. Naturally, there are always exceptions to the rule but try to be economical with your paintbrush!

▲ *The bridge at Potter Heigham.*

## USING REFLECTIONS

The most important way of conveying the feeling of water is by showing reflections, even if there aren't any reflections in the water you are looking at! If you are painting such a scene, I suggest you try adding some imaginary reflections – you will find that this will help to create the illusion of water.

I did the painting (right) from our cabin on the Norfolk Broads. It is a perfect example of working outdoors from nature but, at the same time, making adjustments to get the best out of a painting. The photograph (above) is of the same place, on the same day, but there are no reflections. I decided to leave unpainted white paper to represent water and to paint in simple reflections to help the illusion.

## PUTTING BOATS IN A SCENE

It can be difficult to decide which boats to put in a painting like this, as they are moving in and out of the scene the whole time. I drew the bridge first, then the moored boats. While I was doing this, I spotted a yacht which had just put up its white sails and was casting off, having come under the bridge. It was exactly what I needed and I drew it in. I was still hoping for another craft with character to appear but nothing came along that excited me, so I started to paint.

I had just finished the sky and trees when the yacht moored on the right, which by now had its mast lowered ready to negotiate the bridge, left its moorings and started to be punted towards the bridge. It was perfect so I quickly dropped my brush, picked up my pencil and drew it in – and so that yacht appears twice in the painting!

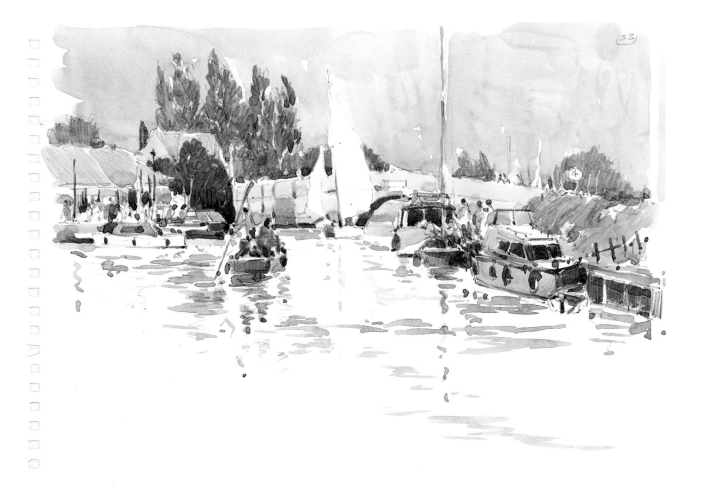

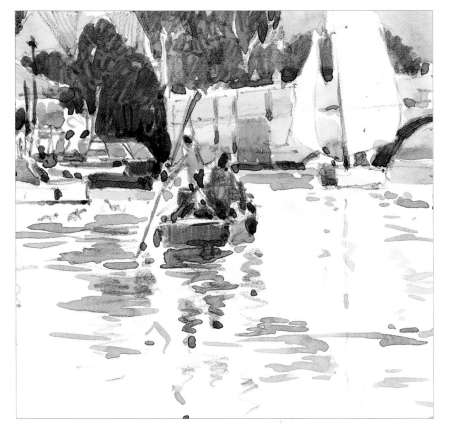

▲ POTTER HEIGHAM BRIDGE
Watercolour on cartridge paper
20 × 28 cm (8 × 11 in)

◄ *Some pencil lines show in the reflections. These, with the simple horizontal brush strokes and the white, unpainted paper are enough to give the illusion of water. Notice how the colour relationship between the background trees and the closer tree on the left works well to give the impression of distance.*

I decided to paint the same scene as on the previous page but in oil this time, and to paint the water as dark as it actually looked on the day and in the photograph (below). The only distinct reflection on the water came from the white sails on the yacht.

## FIRST STAGE

I drew in the bridge, other stationary objects and the boats first as I had done with the watercolour, using my No. 6 sable brush and a mix of Cobalt Blue and Crimson Alizarin. Then I waited for some interesting boats to move through the scene.

When I had nearly finished the drawing, a yacht came towards me. I waited for the sail to show against the dark background and then quickly drew it in. It carried on and I didn't see it again but similar yachts sailed past most of the time and I used these to help as reference while I was painting. I also drew in the two cruisers heading towards the bridge.

Finally, I filled in the dark trees and inside the arch of the bridge.

## SECOND STAGE

I began by painting in the sky with thick opaque paint (adding white to the colours) and worked down to the trees, which I painted next to establish the darkest areas. I used my No. 4 bristle brush for this stage.

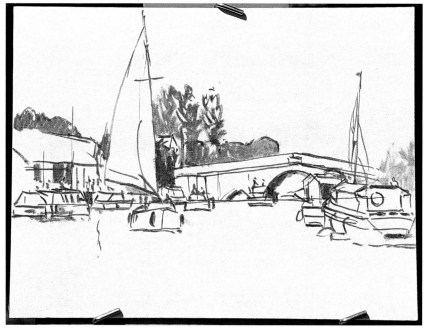

▲ FIRST STAGE

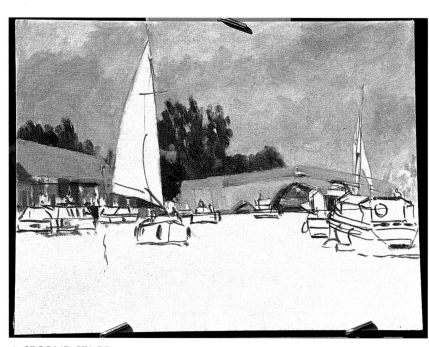

▲ SECOND STAGE

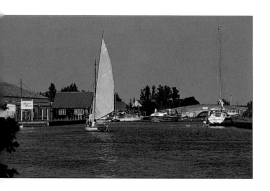

On some of the other oil paintings in the book I started by painting thinly with a very turpsy mix. With this one I didn't and the reason is simple – this time, nature dictated that I worked with thicker paint and I did so automatically!

When you are working from your imagination, sketches or photographs at home, you will find that you apply more technique to the development of a painting. But when you are copying from nature, technique becomes secondary. You paint in whichever way will produce the effect you can see.

Next, I painted the buildings on the left.

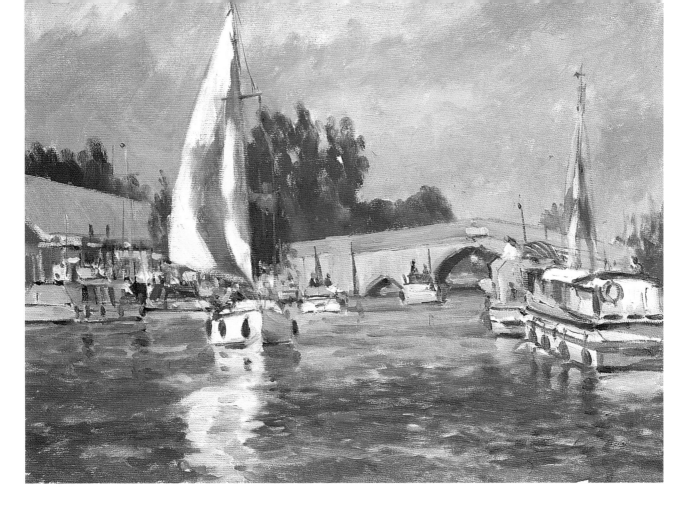

## FINISHED STAGE

Using my No. 2 bristle brush, I painted in all the boats (but not the yacht) starting on the left of the picture and working to the right. This was for practical reasons because it meant I could rest my hand on the unpainted right-hand side of the board while I worked if I wanted to.

You will see that there is no detail on the quay to the left of the yacht, just brush strokes making dark and light shapes.

I then painted the water with a varying mix of the colours I had already used, which were Cobalt Blue, Crimson Alizarin, Yellow Ochre, Viridian and Titanium White. I worked opaquely, but thinly, over the whole area using my No. 4 bristle brush.

Darker paint was worked over the water with horizontal brush strokes to represent movement. I then painted the main yacht with its reflection.

When you compare this oil painting with my watercolour on page 71, you will see two completely different images of the same scene. The watercolour looks bright, sparkling, full of activity and very light-hearted. This painting looks more sedate, mature and 'settled'.

▲ THE BRIDGE, POTTER HEIGHAM
Oil on Daler board
30 × 40 cm (12 × 16 in)

▼ *This detail shows how wet paint was blended together. Notice that there are no 'hard' edges.*

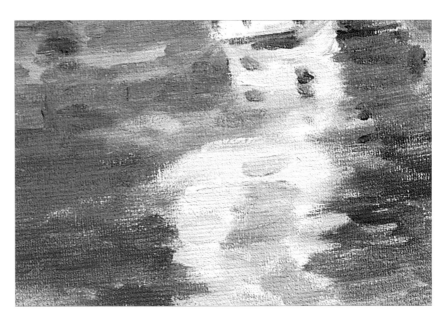

The colour of the sea impressed June and I more than anything else while we were filming in the Bahamas for one of our television series. On the day I did this painting, the sea kept changing from a soft, milky green to the darker blue of the photograph (below). I decided that I would paint it in its green livery.

## FIRST STAGE

I did the drawing of the waterside carefully. If this hadn't looked correct, neither would the sea – which was the inspiration for the painting. I painted the sky first, using my No. 10 sable brush. When this was dry, I painted the light shadows on the buildings and then the trees.

The 'moving boat trick' that I used in my watercolour of Potter Heigham on page 71 came in handy again here. I drew the boat at the end of the jetty and, just before I started to paint the water, it cast off and headed out to sea. I quickly drew it in its new position, thus adding another boat to the scene and giving a little more interest to the water.

## SECOND STAGE

The sea was the most important part of the painting. It may look simple but there were two problems to overcome. Firstly, I wanted to get the correct colour.

▲ FIRST STAGE

▲ SECOND STAGE

Secondly, because it was very hot, I didn't want the wash to dry as I painted it and make the usual unpredictable marks.

I used mainly Coeruleum, Cadmium Yellow Pale and a touch of French Ultramarine and Crimson Alizarin for the sea colour, checking this first on a piece of spare paper to make sure that it was right. I mixed a lot of colour. If I had run out while applying my wash, the paint would have dried before I had time to mix some more and that would have been disastrous. The two colours I mixed were very watery: a yellowy-green and a bluey-green.

Then, with my No. 10 sable brush, I started painting down from the horizon, varying the colours as I worked. I finished by painting the beach.

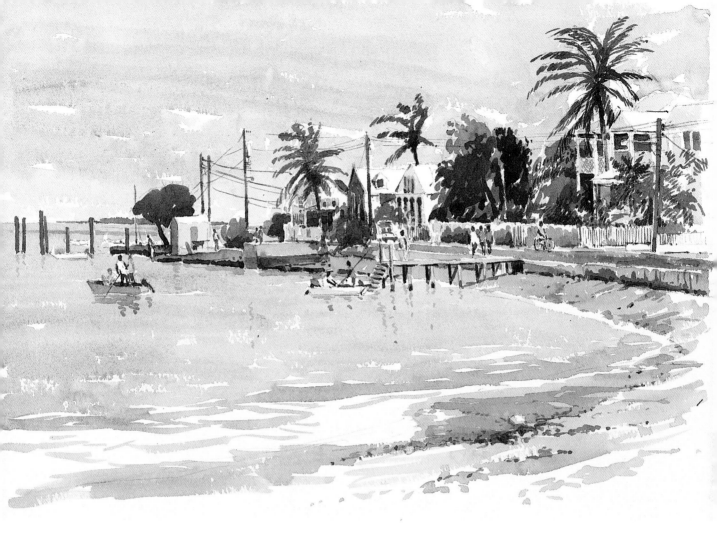

## FINISHED STAGE

I continued adding more dark colours, especially on the trees and houses. The suggestion of the picket fence was important because it gave local character. I then painted the people and the boats. The reflections were very pale and indistinct but I didn't exaggerate them. I hadn't painted in that part of the world before and, with the green sea, this could have looked odd, so I painted what I saw.

▲ THE BAY, HARBOUR ISLAND, BAHAMAS
Watercolour, Waterford 300 lb Rough
38 × 50 cm (15 × 20 in)

◀ *The darker blue horizontal line behind the posts helps to give perspective to the water. Notice how the reflections were made with simple brush strokes again.*

## THREE WAYS OF PAINTING WATER

The paintings on these two pages show three different ways of tackling water. When June painted Potter Heigham Bridge (below), she worked her water with dark colours but made sure that she left unpainted white paper for the reflection of the cruiser. She put a wash of French Ultramarine and Crimson Alizarin all over the water area, again leaving paper unpainted for the reflections. When this was dry, she used a darker colour and, with horizontal brush strokes, worked over the 'blue' underwash, leaving areas showing. She added greens in the water below the trees to show their reflections and, once this was dry, added an even darker colour there. This technique certainly gives the illusion of water.

The water in June's painting (right), which was also done at Potter Heigham, was achieved with just one wash. June used a wet-into-wet technique for this and you can see how the colours have run and mixed together. This time, she didn't rely on tree or boat reflections but the glow from the sky reflected into the river

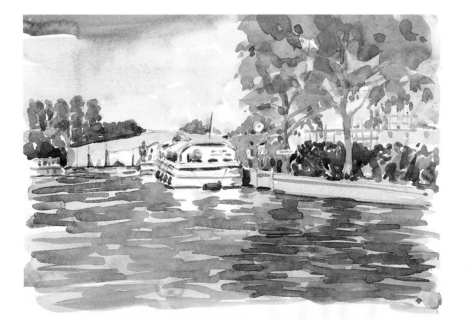

◀ POTTER HEIGHAM
Watercolour on cartridge paper
20 × 28 cm (8 × 11 in)

*The water in this painting looks quite complicated but was still painted very freely.*

▼ *This details shows how, although the water was dark, June retained its luminosity by leaving unpainted areas, which also helped to create the illusion of movement.*

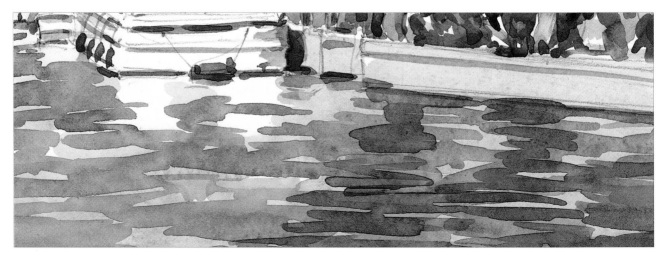

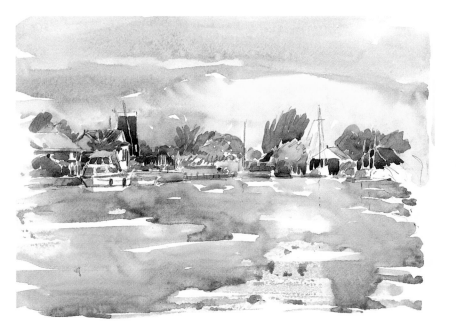

◀ DOWNSTREAM, POTTER HEIGHAM
Watercolour on cartridge paper
20 × 28 cm (8 × 11 in)

*This water was painted more simply than the one on the left because the scene dictated it. June was inspired by the light reflected in the water by the sky.*

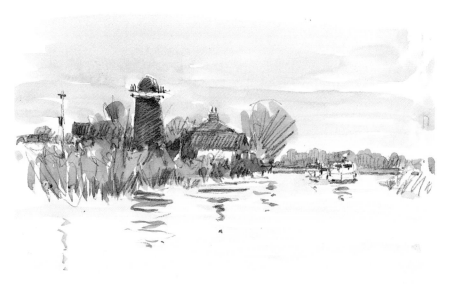

◀ WINDMILL ON THE RIVER BURE
Watercolour on cartridge paper
20 × 28 cm (8 × 11 in)

*This is a good example of how very simple reflections can create the illusion of water.*

helps to give the illusion of water. June put some careful work into the mill and cruiser and these make perfect points of interest, contrasting with the rest of the painting which is free and has a hint of mystery.

My watercolour sketch (above) had to be quick and uncomplicated. We were in a moving boat – and it was June's turn to steer! Once I had painted the sky, I carried on into the water using the same colours and horizontal brush strokes.

Finally, after I had painted everything else in the picture and it was dry, I put in the reflections. I couldn't have given the impression of water in a simpler way.

# SKETCHING PEOPLE

A street scene without people can often look uninteresting and unrealistic. Remember, where people are naturally part of a scene, you must endeavour to put them in. After all, wherever you go in the world, with very few exceptions, you can't get away from them! This doesn't mean you have to be a brilliant figure artist before you can start adding people to your paintings. People in a scene are generally just a part of it, helping to make the whole painting work.

## DON'T ADD TOO MUCH DETAIL

If your buildings are painted freely, your figures should be painted freely, too. Don't add too much detail to them. Just because you see a woman wearing a patterned dress and an enamelled brooch, you don't have to paint these features in. After all, you wouldn't paint every brick in a building, or the numbers on every door in a street!

Try to keep figures in context with your painting. In the close-up of the lavender farm (on page 89), my treatment of the people is very much in tune with their surroundings. They don't stand out particularly but are simply part of the scene and just as I observed them in real life.

Watercolour on cartridge paper in June's A4 sketchbook

*When June did the sketches on the beach (below), she was lucky. The old lady stayed in one place for ten whole minutes, giving June time to do three sketches of her. She drew each of the five figures (right) as three-minute exercises during one of our courses. This teaches you to find shape and form very quickly and disciplines you to focus all your thoughts and creativity on a single subject. You may find this a little difficult at first but, with practice, you will eventually get good results. By the way, you can see that I was the model for our class for a time!*

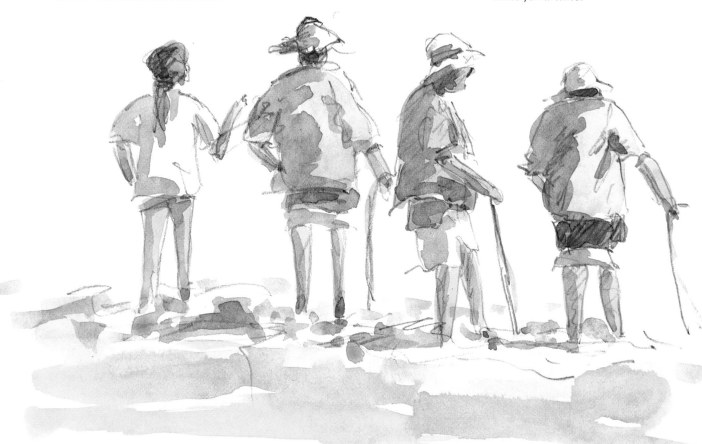

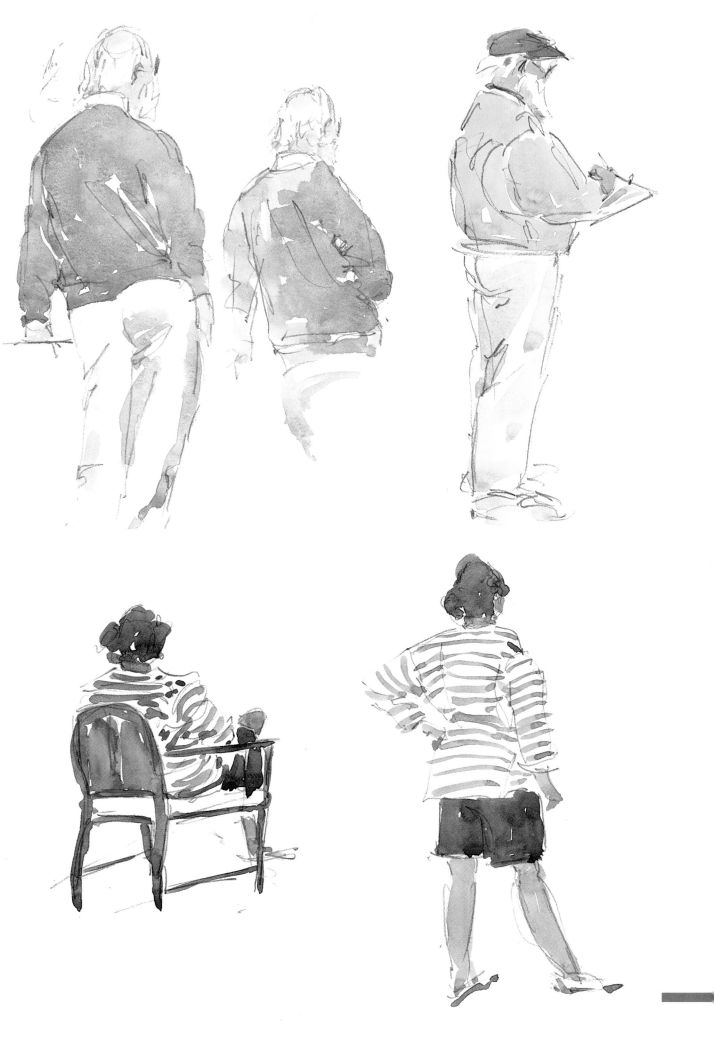

◀ Pen on cartridge paper
5 × 13 cm (2 × 5 in)

*June sketched these three Bahamian women while we waited for our flight to be called at Nassau Airport. Impromptu sketches like this are a great way to pass the time and always bring back lovely holiday memories.*

Practise sketching people using cartridge paper and a 2B pencil. Start by observing your family while they are watching television or working round the house – whatever they are doing, sketch them! Don't concern yourself with detail, just aim for the overall pose and shape. If you are a 'natural' at drawing figures, you will soon be feeling confident. However, if you find yourself having to work hard at it (like I had to when I first started), persevere and you will succeed.

Once you have gained confidence, do some sketches in three minutes (like the ones June did on pages 78 and 79). Then limit yourself to two minutes and, finally, one minute. Quick sketches like this will definitely stop you from fiddling!

▼ Watercolour on cartridge paper
20 × 28 cm (8 × 11 in)

*This sketch was done on a painting course in Provence. The students were working so June didn't have the problem of them moving away! However, she gave herself a time limit of forty-five minutes to paint the students and their surroundings. This is another excellent exercise to practise.*

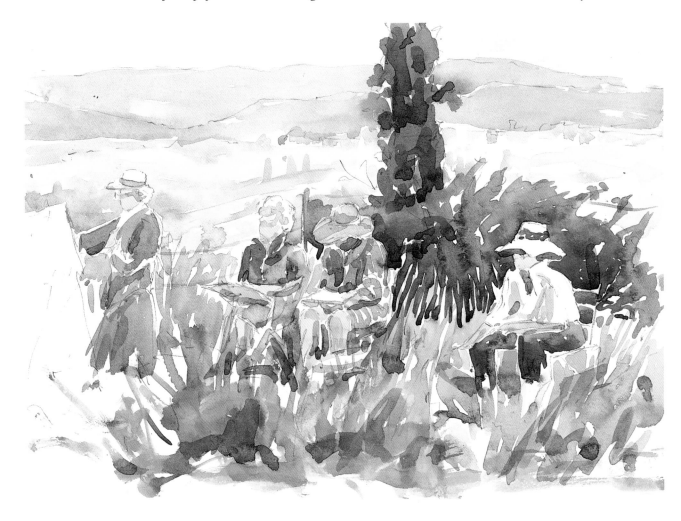

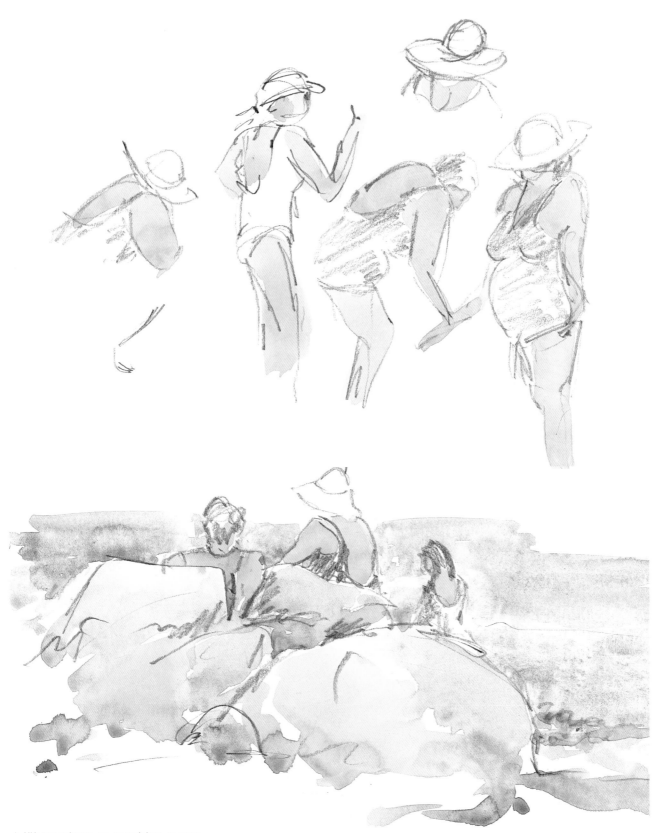

▲ Watercolour on cartridge paper
reproduced actual size

*This typical page from June's sketchbook shows some sketches she did while we were sitting on the beach in Majorca. If you get bored by just sitting on a beach, get your pencil out and sketch! If it is practical, paint as well. Remember, it is a golden opportunity to practise your figure work.*

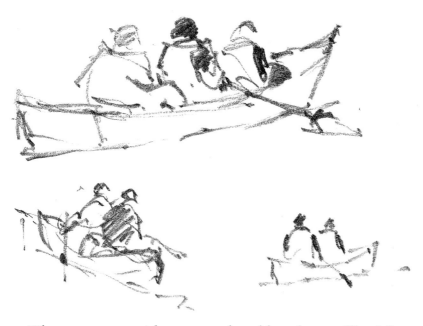

◄ 2B pencil, cartridge paper
reproduced actual size

*I did these quick sketches of
some of our students when we
went down the River Dordogne in
France in a canoe. It was okay
until we hit rapids – then it was
pencils away and both hands on
the paddles!*

When you are outdoors, people seldom keep still while you
sketch them so you must learn to work fast. If you are sketching
a crowd, make sure you draw one or two people carefully. Then it
won't matter if the rest aren't so detailed because they will still be
acceptable as part of the group.

Study the paintings in this book with people in them to see how
these were done and how they work in the context of each
painting. When you first start putting figures into your own
pictures, don't work any larger than my drawings (above). This
will stop you worrying about detail. Half-close your eyes and look
at the way the light and shadows help to make the form of each
figure. Most of the figures you put into your paintings will be very
small. Once you are feeling confident, colour your drawings with
simple washes.

▼ Watercolour on cartridge paper,
reproduced actual size

*Practise painting figures this size,
putting as little work in them as
possible. After working larger,
you will find you can adapt to
this size more easily. I did this
sketch of people waiting for the
arrival of fishing boats while we
were in the Bahamas.*

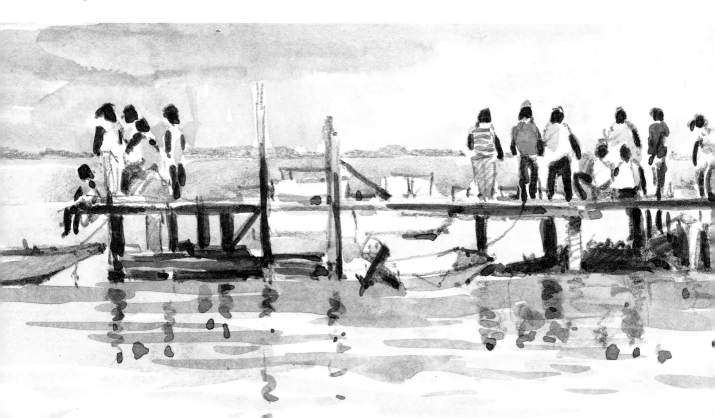

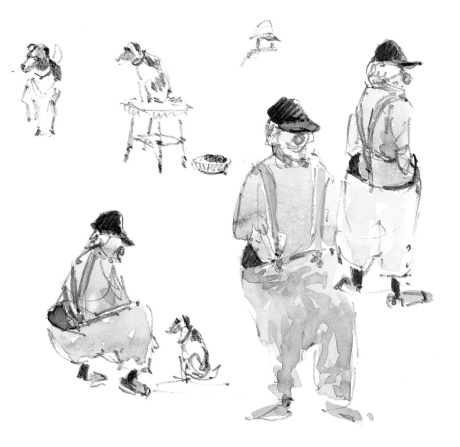

◀ Watercolour on cartridge paper
14 × 17 cm (5½ × 7 in)

*I sketched this French clown and his dog in the main square of the town of Sarlat in the Dordogne. I was just getting the feel of his character when we had a very heavy rainshower. The clown packed up and June and I had to cover our sketchpads and run for shelter. The rain eventually stopped but, unfortunately, the clown didn't come back.*

▼ Watercolour on cartridge paper
15 × 25 cm (6 × 10 in)

*I sketched these two students as a demonstration. Notice how straight-backed one of them is while the other has a very relaxed pose. It is important to capture these personal attitudes.*

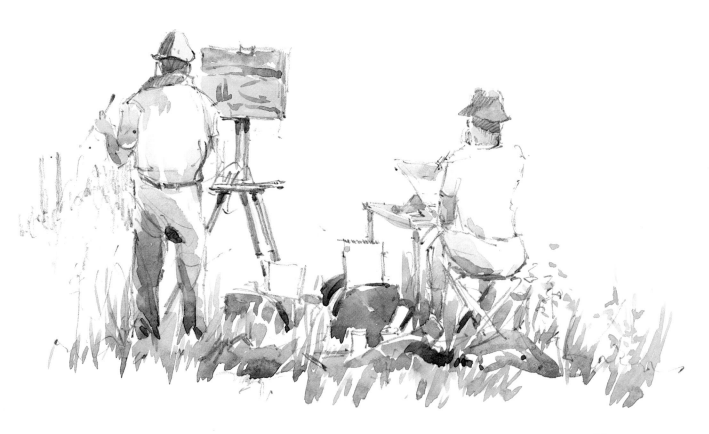

## FROM JUNE'S SKETCHBOOKS

This page shows some of the sketches June did when we visited the circus at Great Yarmouth. These were done in almost total darkness, or in the dazzling display of multi-coloured lights which constantly flashed out into the audience.

The hardest thing about sketching moving people is getting started. At first, you will probably find your drawing isn't very good but, if you persevere, your sketches will get better by the minute.

As you relax and get into the characters you are sketching, your pencil strokes will become much freer and you will begin to get the feeling of your subject as you draw.

Of course, there is no way that you could do a full-blooded painting of a circus like this. You would need the characters to pose for you or to watch them do their act over and over again. You would also need better lighting conditions. If you want to do a circus painting, it is better to work at home using your sketches and memory. Also ask permission to take some photographs of the acts so that you can use these as reference.

The sketches on the opposite page, apart from the one shown bottom left which June did during a coffee break while were were in Montmartre in Paris, were all done while travelling, during 'waiting time'.

All the sketches were done approximately one-third larger than is reproduced.

# COLOURFUL SCENES

When you are painting a colourful scene, do try to play up the colours – don't be afraid of them, or you will be disappointed with your painting. At times this takes a lot of courage! I find it harder to paint with strong colours than June does so I have to be very positive when I do this type of work.

June and I had heard of a lavender farm in Norfolk and decided it would make a colourful painting. We were lucky on the day we went there because the sun was out and it was very warm. We passed through a village on the way that would have made a great painting but decided to continue to the lavender

▲ *Norfolk lavender farm.*

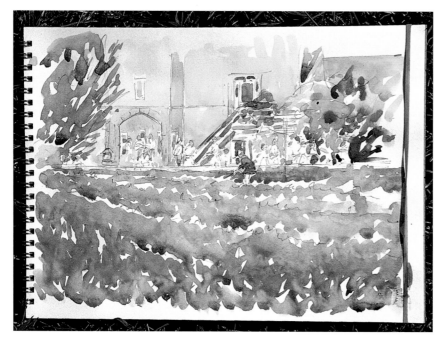

▲ *In this first stage, June drew the scene with a 2B pencil and then painted a wash on the main house and the adjacent roof. When this was dry, she established the stairs and the trees and put some flesh colours on the people. At this point, a gardener came across the field and June drew him in.*

*June wasn't faint-hearted when she painted the lavender! Using*

*clean water and a mix of French Ultramarine and Crimson Alizarin (adding a little Hooker's Green No. 1 in places), she held her breath and painted it in.*

*June added Yellow Ochre at the very bottom of her picture – again holding her breath – but it worked. I had moments like this when I painted the water in my picture in the Bahamas (shown on page 75).*

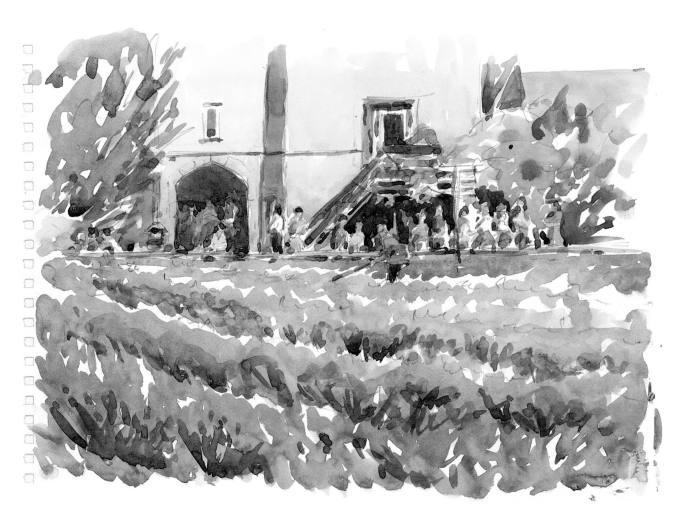

farm and paint it on the way back. However, when we returned there on our way home, the scene looked flat and uninteresting because the sun was in a different position. When you see something, paint it – you may never see it like that again!

When we arrived at the lavender farm, it was very crowded but we found a quiet spot with a view of the farm at the edge of a field full of lavender. As usual, June chose a more intimate view than I did and painted an interesting close-up view of the farm, with tourists wandering about, for her painting. She was very pleased with the result.

▲ FIELD OF LAVENDER
Watercolour on cartridge paper
20 × 28 cm (8 × 11 in)

*June worked a dark colour behind the people and in the archway, then put a shadow on the building and painted the window and door. Finally, she added some darks to emphasize the rows of lavender.*

◄ *June wasn't afraid to use strong colour for the lavender but this didn't overpower the painting because she also used strong colours in the background. Notice the lines in the rows of lavender – these help to make the field look flat.*

# DEMONSTRATION
## Lavender Farm, Norfolk

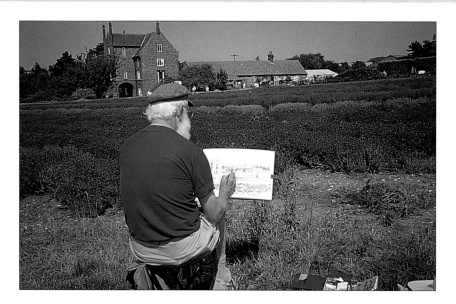

When I first saw the lavender farm, I was tremendously inspired by the colours. However, I must admit that I was a little nervous, too. The red brick roof of the long building, the yellow sun umbrellas and the brightly-clad people, together with the vast amount of purple lavender dominating the whole scene, certainly felt like a challenge. But I let myself go and, like June, enjoyed every minute of it.

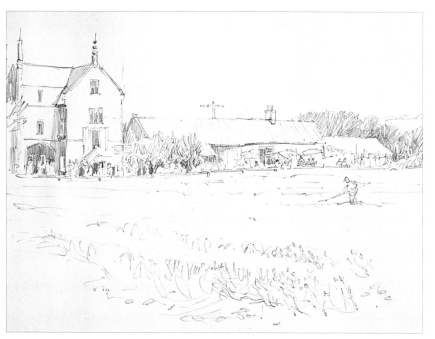

▲ FIRST STAGE

### FIRST STAGE

I started by positioning the building on the left and the long red roof. When I was happy with these, I put some detail on the buildings and drew in the people in front of them.

At this point everything was established. I then shaded areas to give depth to the drawing. I often work this way on cartridge paper. While I was doing this, the gardener came into view and, as June did in her painting on the previous page, I drew him in.

▼ SECOND STAGE

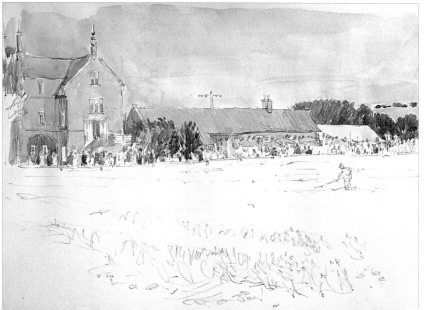

### SECOND STAGE

I painted the sky with my No. 10 sable brush. Next I put in the red roof and the building on the left using a mix of Cadmium Red and Cadmium Yellow and then let this dry.

I painted the trees, the people and the yellow sun umbrellas and, when this was dry, I added some darks to the trees, buildings and windows. In fact, in the heat, the paint was drying almost as fast as I was working!

## FINISHED STAGE

The time had come to paint the lavender. I felt quite nervous because, if this next stage didn't work, the whole painting would be ruined!

With such a large area of an unusual colour, I made sure, as June had done in her painting, to emphasize the rows of lavender to help break up the mass and give it form. I also used clean water, so that the colours stayed bright and fresh.

I worked over it three times (each time allowing the paint to dry), lastly adding detail and dark colours. I then painted in the gardener and added a few more dark accents where I felt the painting needed it.

I was thrilled with this painting and felt, like June, that I had done the colours justice. We had a wonderful day at the farm and it was well worth the visit, even though we didn't paint the village on the way home!

▲ THE LAVENDER FARM
Watercolour on cartridge paper
28 × 40 cm (11 × 16 in)

▼ *Notice how the figures in the distance are created by simple brush strokes.*

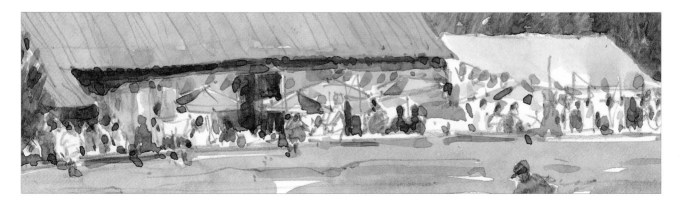

▲ FIRST STAGE

When we were in the Bahamas, June was attracted to the view at the back of a brightly-coloured market stall on Harbour Island. While she was painting this, I was only a short distance away, busy working on my painting of the shoreline (shown on page 75).

### FIRST STAGE

June positioned the main side of the stall first, then the tree and the fence. Next she drew any other features that she needed to help her when she painted. She didn't put in any shading this time. As I said earlier, nature often dictates how we work when painting outdoors and June didn't feel she needed to do any pencil tonal work for this particular subject.

The blue of the stall was painted with a mix of Coeruleum Blue and French Ultramarine. Then June put in the yellow stall, the grey wooden fence, added a little detail and, finally, painted the trees.

### FINISHED STAGE

The foliage on the trees and the grass were painted next. Shadows were put on the tree trunks, the wooden fence, the grass and the side of the stall.

When June spotted two people through a doorway, in shadow, she drew them in and painted around them with a dark colour to represent the open door. Later, she felt these figures could have been more prominent.

▲ THE BLUE MARKET STALL
Watercolour on cartridge paper
20 × 28 cm (8 × 11 in)

90

While June and I were in Paris with my twin sister Shirley, celebrating Shirley's and my sixtieth birthday, we went for a boat trip on a Bateau-Mouche on the River Seine. We each did a painting looking towards the Eiffel Tower before we boarded the boat. The scene was full of colour and activity.

### FIRST STAGE

I did the drawing with a 2B pencil. The most important aspect was to get the scale correct. I drew positional marks on the paper, then worked the tower putting in quite a lot of detail and shading.

I did this because I intended to leave the pencil showing and the tower unpainted. I then put more detail into the rest of the drawing.

### FINISHED STAGE

I painted the sky very freely, working over the tower. Then I painted the trees and buildings below it and a suggestion of activity and people there. I wish I had allowed enough paper to add more at the bottom of the sketch but there's no answer to that!

I left the flags until last because of their bright colours, but I think I could have been more adventurous and painted them with stronger colours. However, a painting like this brings back fabulous memories – one of the many advantages of painting on your travels.

◀ FIRST STAGE

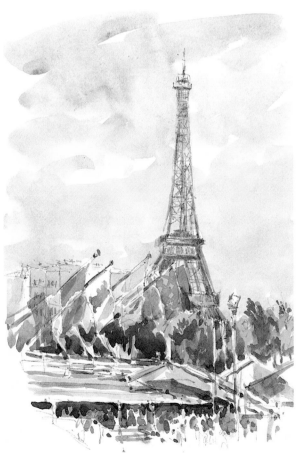

▶ FLAGS AND THE EIFFEL TOWER
*Watercolour on cartridge paper*
*28 × 20 cm (11 × 8 in)*

## FROM ALWYN'S SKETCHBOOKS

I did the first sketch while sitting having a coffee in Montmartre. I would have liked to have done an oil painting but there wasn't time because the scene was very complicated – it was full of artists, easels, paintings on display and tourists.

I decided to use the old gas street light as my focal point and drew this carefully. I didn't draw any tree branches over it or it would have lost its shape. I also took care with the lettering on the café wall. The rest of the sketch was less important.

The sketch below this was done in the Bahamas. It could be used as reference for a freestyle painting at home but, if I wanted to work more detail into it, I would also need to use a photograph.

The sketches at the top of the next page were done standing at the stern of our car ferry as we left St Malo harbour in France. These were all done in about twelve minutes and they bring back memories of a wonderful week in Brittany.

Notice how much lighter the pencil is on these sketches than it is on the ones below them. This is because, when you work standing up – and, in this instance, the ferry was underway – you can't get the same pressure or control on your pencil as you can when sitting down and resting your pad on your knees.

I was sitting comfortably on the beach when I did the last sketches.

The sketches on these two pages were done approximately one-third larger than they are reproduced here.

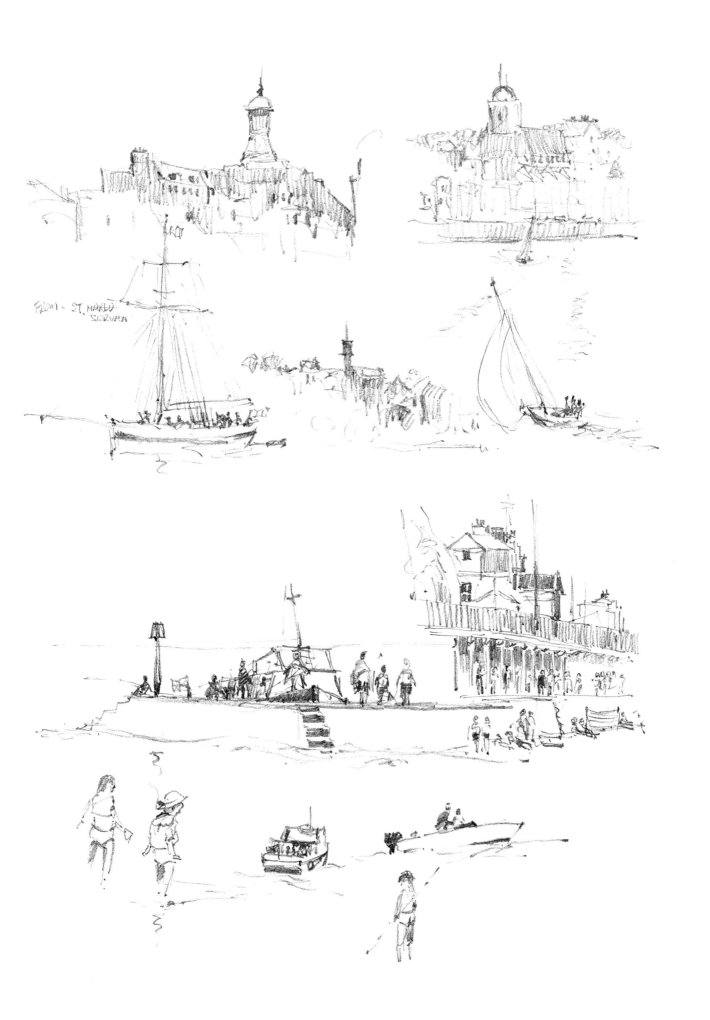

FROM - ST. MALO
SORUAN

# PAINTING
# BUILDINGS

You really do need to have a basic knowledge of perspective to be able to paint buildings successfully. Even with a good grounding in perspective, it's sometimes difficult to get a building to look like a solid structure!

Start by drawing simple, uncomplicated buildings that aren't too large to help you learn about perspective. Don't try to paint a city street, full of shops and people, the first time round. Draw parts of buildings to get used to the structure of doors, windows, chimneypots, drainpipes and other architectural features.

## INCLUDING OTHER ELEMENTS

Buildings rarely stand alone. They usually have trees or other buildings around them or elements like people, traffic or a river obscuring parts of the building you are painting. It's amazing how a branch of a tree can camouflage areas that you are not sure of and this can be quite useful at times. But you mustn't let this stop you practising your drawing and perspective.

I did the painting of the Sacré-Cœur, shown on the opposite page, during my sixtieth birthday trip to Paris. This impromptu sketch was done while we were having a coffee, outside a typically Parisian café. From our viewpoint, there were no other buildings in sight and the Sacré-Cœur stood isolated and looked very impressive. We had been walking and sketching all day and I felt happy and relaxed but still ready for a challenge. While I painted this, June did the small sketch (right) and then enjoyed another coffee but I was far too busy working to stop!

## MEASURING DISTANCES

It was important to get the proportions of the different sections of the building correct. I did this by measuring the distances with my pencil. Once these were plotted in, I shaded the dark areas and then painted simple washes over the drawing. Both my drawing and painting were very delicate. I think this was because I was beginning to feel rather fragile myself, having walked and sketched around Paris all day!

▲ 2B pencil on cartridge paper
15 × 12.5 cm (6 × 5 in)

*June sketched the Sacré-Cœur quickly, then relaxed with a cup of coffee. Small sketches like this really enhance your travelling sketchbook, as well as giving you a tremendous feeling of satisfaction.*

▶ SACRÉ-CŒUR, PARIS
Watercolour on cartridge paper
28 × 20 cm (11 × 8 in)

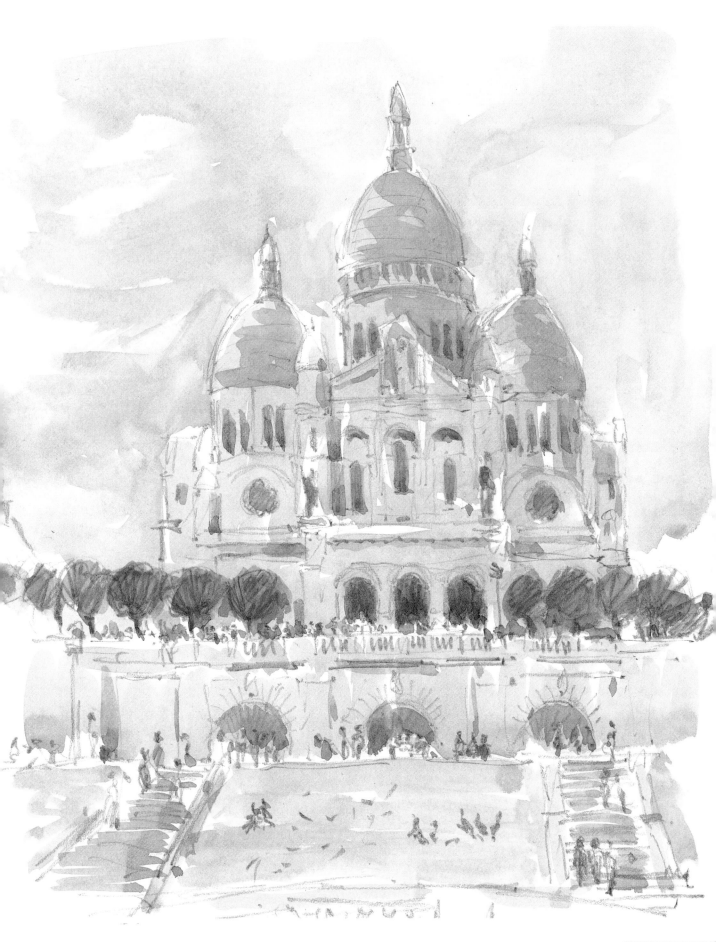

# DEMONSTRATION
## View from Bénodet, Brittany

During our trip to Brittany, we decided to look for buildings to paint. Naturally, they were everywhere but we wanted something that inspired us.

At Bénodet, near where June painted the yachts in sunlight (shown on page 31), I saw the view in the photograph (below). June looked at me and must have seen the sparkle in my eyes. 'This one is yours, isn't it?' she said. I replied, 'Definitely!'

I sat on a bench and started drawing excitedly. This scene was too extensive for June, who went further along to find a more intimate view.

### FIRST STAGE

I positioned and drew in the top of the quay and the church tower. Then, working to the left and then to the right, I drew the buildings in outline only. (I used my putty eraser a few times while drawing because it was quite a complicated drawing.)

Then I put some detail into the buildings and worked down and drew the boats. Finally, I shaded in the dark areas with pencil.

### SECOND STAGE

I started painting the sky and worked over the buildings and harbour wall. However, at this stage I left the roofs of the buildings unpainted.

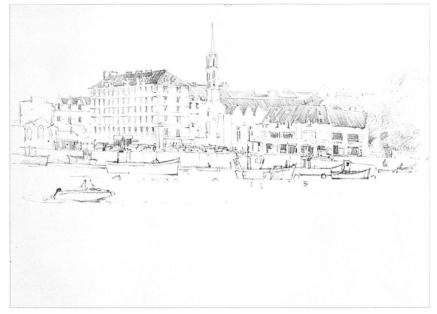

▲ FIRST STAGE

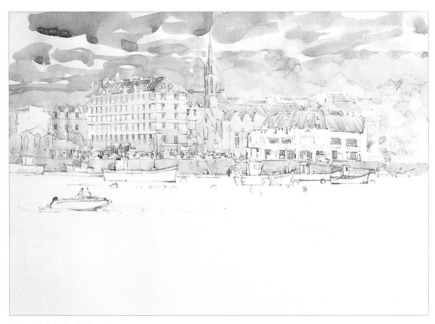

▲ SECOND STAGE

▼ THIRD STAGE

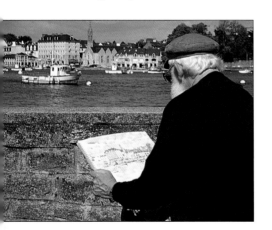

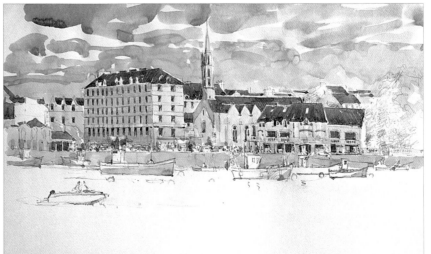

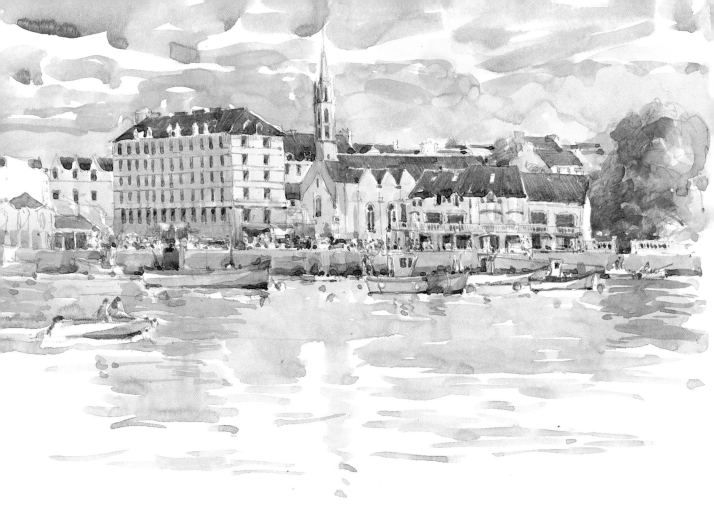

### THIRD STAGE

This stage gave substance to the buildings. I painted the roofs, the windows and the dark areas on the quay. I also put a pale wash on some of the boats.

### FINISHED STAGE

I added more detail to the quay and the trees with my No. 6 sable brush, then put in the fishing boats. I painted the water very simply because I didn't want it to detract from the buildings, but the reflection of the church tower was important as this helped to give the illusion of water.

While I was drawing the scene, a large passenger boat that was moored on the quay moved away after I had carefully drawn it in! So I rubbed it out and drew in the buildings which then became visible – which incidentally made the painting more interesting.

▲ BÉNODET, BRITTANY, FRANCE
Watercolour on cartridge paper
28 × 40 cm (11 × 16 in)

▼ *The windows, especially on the large building, are important. I counted them and then drew their positions in pencil. When I painted them in, I used single brush strokes.*

While I painted for the demonstration on the previous page, June found an ideal painting spot at the end of the small harbour. She saw the pink house and the curve of the upturned boats leading to the house and was inspired by the scene.

She drew the house first and used pencil lines to establish the curve of the boats and the quay. Then she drew in the pink buildings on the right and left of the house.

The boats were drawn very freely. June left out the one which was laying on the beach, the right way up, because this would have spoilt the flow of the simple curve up the beach to the house.

The sky was painted first, then the pink house, the buildings each side of it and the boats. When this was dry, she painted in the trees and the beach. Finally, dark colours were added where necessary. The buildings were painted very loosely, maintaining a feeling of freedom throughout the painting.

▲ *The pink house near Bénodet, Brittany.*

◀ THE PINK HOUSE
Watercolour on cartridge paper
28 × 20 cm (11 × 8 in)

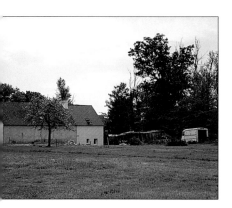

After June had painted the orchard of trees in blossom (shown on page 49) and had a cup of coffee, she started looking for something else to paint. Isn't creative energy marvellous? She found this farmhouse with a single tree in front of it.

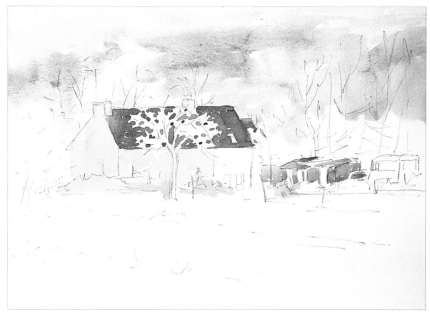

▲ FIRST STAGE

## FIRST STAGE
June established the farmhouse, the sheds and the old van on the right of the picture. The trees in the background were drawn without any form, as this would be done later with brush strokes.

Next the tree in blossom was drawn in and June also put some lines in the foreground to illustrate perspective.

The sky was painted, then the building and the roof, but some areas were left unpainted to represent blossom. Finally, June painted the old sheds.

## FINISHED STAGE
The green areas and the path were painted next. Then, using a colour mix of various greens, June painted the background trees. She made these very dark to the left of the house to give crispness and solidity to the building.

The windows were painted next. Notice how the shadows on the windows recede, giving the impression of thick, solid walls. The blossom was worked over the roof, leaving some white flecks of

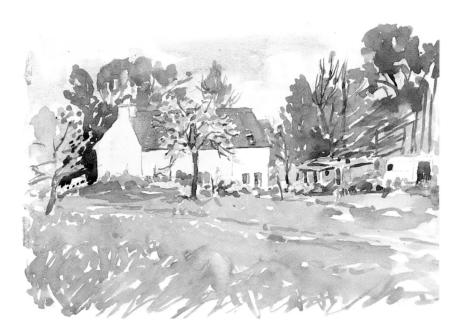

white paper showing through to represent light. Finally, some dark colours were applied to the sheds and van and on the ground in front of the farm.

June decided that, if she painted the dark area in front of the building (see the photograph), it would make the building look more three-dimensional but wouldn't help the painting. She decided to leave it as it was, and I think she was right to do so.

▲ BRITTANY FARMHOUSE
*Watercolour on cartridge paper*
*20 x 28 cm (8 x 11 in)*

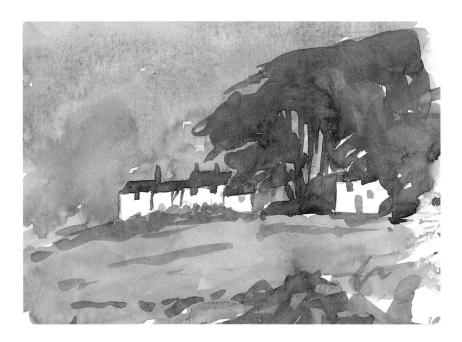

◀ ILKLEY MOOR
Watercolour on cartridge paper
15 × 20 cm (6 × 8 in)

June did the sketch (above) late one evening on Ilkley Moor, after a long journey by car to Yorkshire. I was also painting and we were both being eaten alive by mosquitoes – what we do for the sake of art! We didn't want to stay there long, so we both did a quick sketch. In spite of the mosquitoes, June has captured the character of the stone cottages on the hill perfectly. They were left as white unpainted paper and they stand out strongly against the dark sky and trees.

June painted the very solid-looking houses (below) on one of our trips to Jersey. She did the drawing carefully but the sunlight and shadows help to create the feeling of sturdy, well-matured buildings. The trees and shrubs in front also help to stabilize the houses and keep them firmly on the ground.

▼ FROM A FIELD IN JERSEY
Watercolour on Bockingford
200lb paper
10 × 20 cm (4 × 8 in)

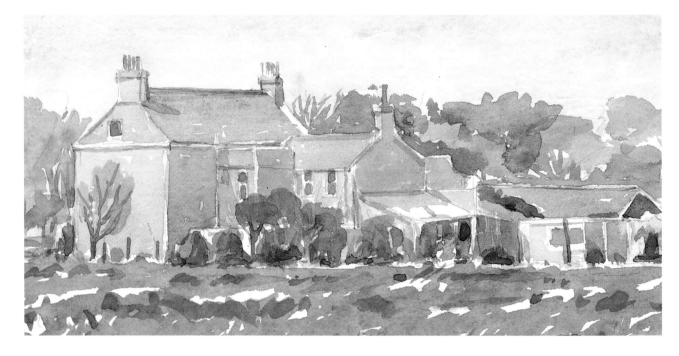

▼ THE ROYAL CHANCELLERY,
GRANADA, SPAIN
Watercolour on cartridge paper
20 × 20 cm (8 × 8 in)

*I did this sketch of the Royal Chancellery in Granada while standing looking over a parapet from the watchtower. I was inspired by the dramatic perspective of the building and drew it first with a 2B pencil. Like the buildings in June's painting on the previous page, the sunlight and shadows help to give dimension and solidity to the structure.*

# WORKING
# IN A HOT CLIMATE

Perhaps it may seem obvious but the most common problem when painting in a hot climate is sunburn! I learnt this lesson many years ago one very hot afternoon when we were painting on the beach in Brittany. I was wearing swimming trunks, a T-shirt and my cap. Quite naturally, I became very involved with my painting and worked solidly for about two-and-a-half hours. I enjoyed doing the painting but had to keep covering up my watercolour box, as children kept running past, sending fine, dry sand flying in all directions – another hazard of working outside.

That evening, my shins felt as if they were on fire and I suffered for five days from badly-burned legs. I had covered up everywhere else and didn't think of my legs. So, a golden rule is always protect yourself against sunburn. Above all, if you can't find shade to sit in, wear a sunhat – and don't leave your legs exposed!

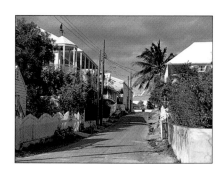

▼ STRAWBERRY HOUSE, HARBOUR ISLAND, BAHAMAS
Watercolour on cartridge paper
20 × 28 cm (8 × 11 in)

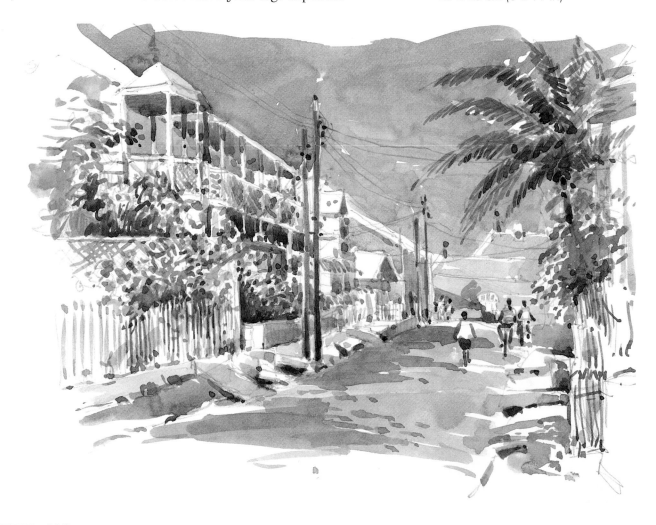

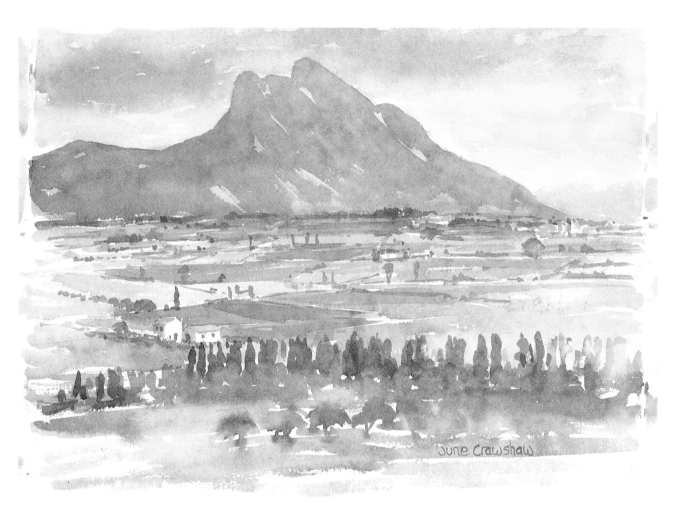

## DRAWING IN HUMIDITY

Something we hadn't expected to encounter while painting in the Bahamas was damp paper! However, we found that the humidity we encountered there affected cartridge paper in particular. A pencil will only give you about fifty per cent of its strength (blackness) when you draw on damp paper. This can happen when you are out working on a dank autumn day in England but we hadn't expected it in such a hot climate.

Unfortunately, we didn't find an answer to this particular problem. We even tried using our hotel hair dryer on the cartridge paper but this didn't help. I suppose the only solution in such circumstances is do less drawing and more painting.

## COPING WITH FAST-DRYING PAINT

Working with watercolours is more difficult in hot weather because the paint can dry too quickly as you apply washes and leave unwanted shapes and blemishes. The only way to stop your washes drying too quickly is to use very watery paint. But don't be too concerned about things like this when you are working outdoors. It is all part of working from nature.

Apart from the heat, I also had to cope with a complicated drawing when I did the painting (left). Remember, until you are confident with drawing, only paint simple scenes.

▲ FROM ANTEQUERA, SPAIN
Watercolour on Bockingford
200lb paper
25 × 35 cm (10 × 14 in)

*It was a very hot day when June did this painting. Fortunately, she didn't have any large washes to contend with since the fields were almost all individual colours. June used a lot of watery paint to cope with the foreground trees. She didn't want any more detail in this part of the painting, otherwise she would have painted over the trees again to give them more shape and form.*

I saw this scene when we first arrived to start filming on Harbour Island and was tremendously inspired by the green building at the top of the road.

I was also fascinated by the chickens and cockerels that wandered about constantly but still managed to avoid the passing bicycles, cars and dogs!

It was my type of scene, full of space, yet still complicated. It was extremely hot and, naturally, the paint dried very quickly as I worked.

## FIRST STAGE

I started by positioning the green building and then the road with my 2B pencil. I drew the figures and chickens into the scene as they appeared. Detail at this stage wasn't important but the correct proportions and positioning of the elements was. I would add detail with my brush later.

Like June's painting on the previous page, I didn't have to apply washes to any large areas, except the sky. However, if you look carefully at the sky, you will see a very slight 'run back' which looks like a cloud. That was lucky!

I used French Ultramarine, Coeruleum Blue, Crimson Alizarin and a touch of Yellow Ochre to paint the sky and then I put in the green building, some roofs and the trees. I didn't paint over the two telegraph poles.

## SECOND STAGE

I painted the road using the same colours as the sky. The yellow areas on each side represent sand. I then put a little more work into the buildings.

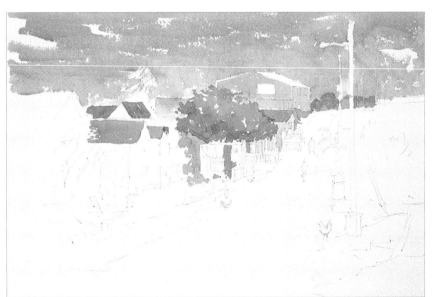

▲ FIRST STAGE

▼ SECOND STAGE

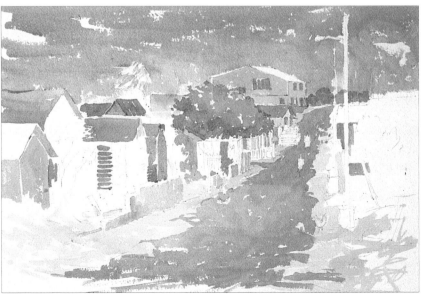

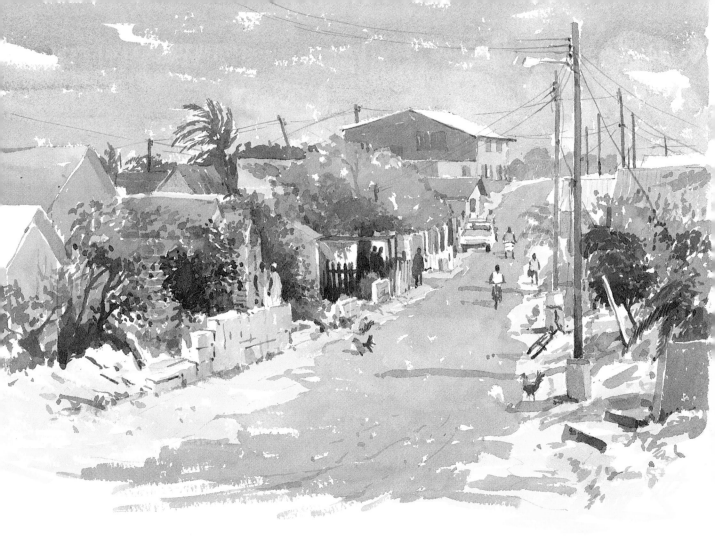

## FINISHED STAGE

It is impossible to tell you exactly how I finished the painting, except to say that this was a continuing process of adding colour and darker tones to give shape and form. For example, the stone wall was created very simply with just a few brush lines (see the detail, right). It was only through careful observation that I knew where to put them.

The area of dark shadow with the two people under the tree is important to the painting because it helps to convey a feeling of strong sunlight. I also put the telegraph wires in because, for me, they were part of the scene.

▲ THE GREEN HOUSE
Watercolour on Waterford
300lb Rough paper
38 × 50 cm (15 × 20 in)

▼ *This wall was created with one wash and simple lines. This detail shows how I left white paper unpainted for the sunlit areas. This helps to give three-dimensional form to the painting.*

▲ FIRST STAGE

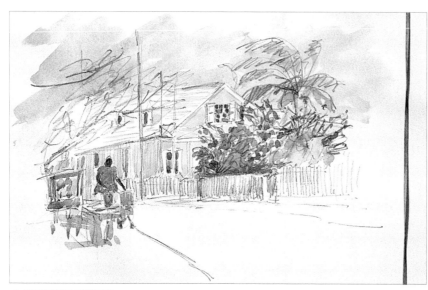

▲ SECOND STAGE

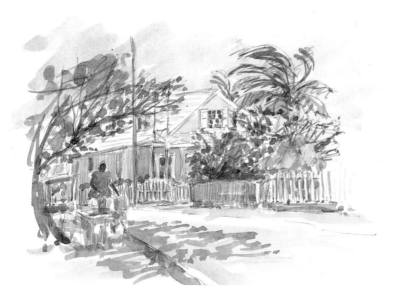

Common sense prevailed when June did this painting of Henry's House on Harbour Island! She would have preferred to paint a different view but would have had to sit in the sun in order to do it. For this one, she could sit in the shade. However, she also liked this view, with the tree and the palm almost making an arch in front of the yellow house.

### FIRST STAGE
June started the drawing using her 2B pencil and drew the house, the road, the picket fence and the trees first. The stallholder came into view, so June drew her in, too. Her pencil marks are much stronger than normal, but this wasn't done consciously.

### SECOND STAGE
The sky was painted first with a No. 10 sable brush. Then June put in the yellow house, the blue stall to the left of it, and the stallholder, dressed in red.

When this was all dry, the bushes and palms were painted and dark areas were added for the windows.

### FINISHED STAGE
Then June painted the shadow on the side of the house and fence. The tree was then painted and she exaggerated the curve a little to help the composition. Finally, she put in the flagpole and the shadows on the road.

Apart from the sky, June used a No. 6 sable brush for the whole of this painting.

◀ HENRY'S HOUSE, HARBOUR ISLAND, BAHAMAS
Watercolour on cartridge paper
20 × 28 cm (8 × 11 in)

# DEMONSTRATION
## The Meeting, Harbour Island

▲ FIRST STAGE

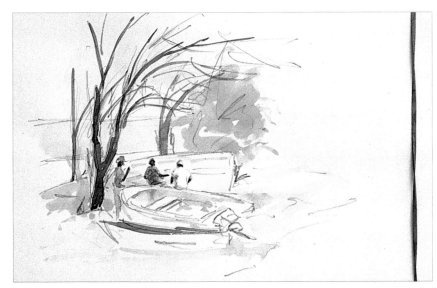

▲ SECOND STAGE

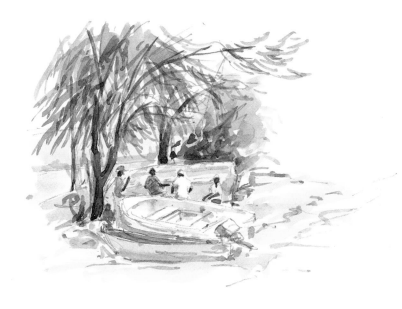

June did this sketch while we were waiting for a water taxi at Harbour Island. When she began there was just one man working on the boat but, while she was drawing the scene, two more workmen joined him. Because she was still at the drawing stage and hadn't started painting, June drew them in as well, which made for a more interesting composition.

### FIRST STAGE
June drew the two boats first and then positioned the group of figures around them. After that, she could relax and draw in the trees because these were not going to move! Sure enough, when June had just finished her sketch, the blue boat set off! If it is practical, always draw potentially mobile objects first.

### SECOND STAGE
Using her No. 6 sable brush, June now painted a background wash of Yellow Ochre and Crimson Alizarin. Then she painted the green bushes, the tree trunks, the boats and the men and, finally, the beach.

### FINISHED STAGE
The foliage was painted on the trees next. As June was finishing this, another man joined the group of workmen. June was lucky because she still had a light-coloured area where she could paint him in. Then the water taxi arrived just as she was adding some dark colours to finish the sketch – all in all, June timed everything perfectly!

◄ THE MEETING,
HARBOUR ISLAND
Watercolour on cartridge paper
20 × 23 cm (8 × 9 in)

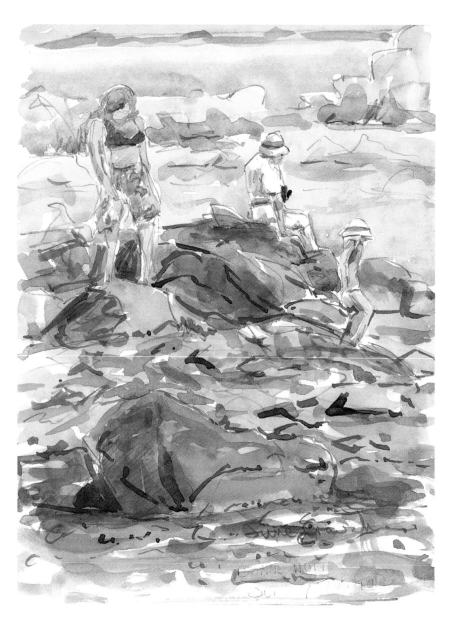

◄ BONNE NUIT BEACH, JERSEY
Watercolour on cartridge paper
20 × 15 cm (8 × 6 in)

*June painted this sketch using very warm colours. This, together with the figures (especially the two with sunhats), tells the story of that hot day on the beach on Jersey perfectly.*

When we were visiting Jersey, we went to the beach at Bonne Nuit. Once again, it was a very hot day and, while I painted boats in the harbour, June sketched some people on the beach (above). She used warm colour mixes to reflect the strong colours of the rocks and beach. I particularly like the way the heat seems to be affecting the figures in the painting – both the adults look quite droopy and the little girl is reluctantly deciding to go back under some shade.

## DRINK PLENTY OF WATER

If you are painting in a hot climate, always remember to take plenty of drinking water with you. A couple of years ago, when we were tutoring students on a painting holiday in Majorca, the temperature was often extremely high. Apart from making our watercolour painting difficult, we had to drink liquids almost continuously in order to keep going, or we would have fainted from the heat!

◄ FORNALUTX, MAJORCA
Watercolour on Bockingford
200 lb paper
40 × 28 cm (16 × 11 in)

*The point of interest was the array of fruit outside the shop. I didn't put any detail into the car because this would have distracted from the fruit shop.*

▼ *I wonder if my legs always look like this when I'm painting!*

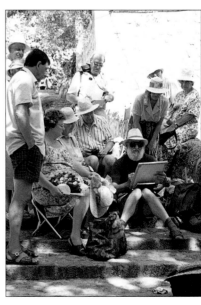

I did the painting (above) in Fornalutx as a demonstration for our students during that trip. It was extremely hot and I sat on some steps as they gathered round to watch me while I painted (see the photograph, right). The object was to show how to paint in conditions where paint dries quickly. As I said earlier, there is no great secret, except to use plenty of water. But I was very lucky because I didn't have any large washes to cope with that day!

## PUT IN THE FLAVOUR OF YOUR SCENE

Notice how the left-hand side of the tree trunk looks light against the dark of the shop window but dark against the yellow wall of the building in the background. When someone came in front of the shop and parked their moped, I decided to put it in since I felt it gave a continental flavour to the painting.

Always remember to observe carefully and make sure you put things into your work that give the atmosphere of the scene, and its location.

# COPING WITH RAINY WEATHER

We always think that, if we go to a hot, sunny climate, we will miss the rain. But, of course, it doesn't always work like that. When June and I were in the Bahamas, we had our share of rain. In fact, there was a terrific storm one night when we were staying on Harbour Island, and all the electricity was cut off until noon the following day!

Showery weather can be extremely irritating when you are painting outside. You start off working in the sun but suddenly

▲ *When it's raining, June and I often resort to the shelter of our car to carry on painting.*

◀ THE STILE
Pen and ink on Ivorex board
20 × 13 cm (8 × 5 in)

*This was done out of the train window. The train stopped for seven minutes and I had to work fast. This type of quick sketch, done under pressure, is excellent for learning how to observe.*

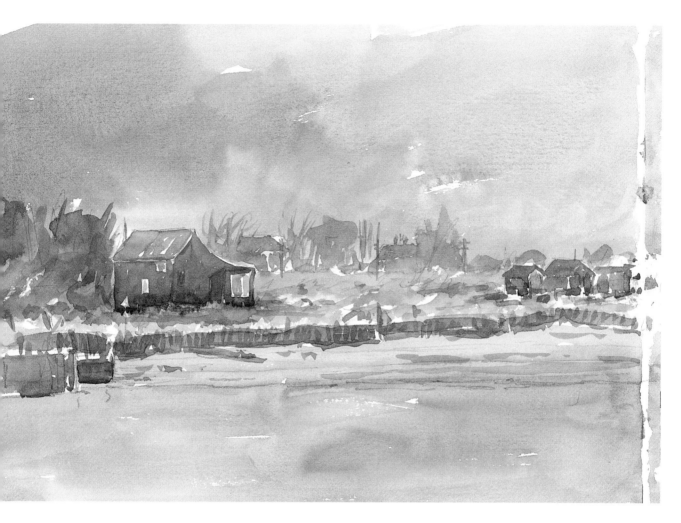

there's a heavy shower of rain for ten minutes or so. Then sun comes out again but, before long, you feel those tell-tale splashes of rain. Also, have you noticed that often, when you finally decide to pack up and go home, the weather suddenly seems to settle and a perfect evening starts to unfold? I am sure that this must happen to artists the world over!

## FIND SUITABLE SHELTER

As with hot weather, the ways around working in the rain are fairly obvious. Naturally, you can't do a watercolour in the rain but you can still work if you take cover and paint looking through a café window, from your car or under a big umbrella (as long as it is not too windy).

I did the pen-and-ink sketch (left) from the train window when we were travelling up to London. We had stopped because there were sheep on the line – or so we were informed! Incidentally, it was raining outside, so I haven't cheated by showing it here!

June did the painting (above) looking towards Walberswick in Suffolk while sitting in the front seat of the car. The rain was simply pouring down the whole time that she was working and June had to keep wiping condensation off the windscreen to be able to see through it. However, it certainly made this an atmospheric painting!

▲ TOWARDS WALBERSWICK
IN THE RAIN
Watercolour on cartridge paper
20 × 28 cm (8 × 11 in)

*The sky, grass, beach and water were all painted wet-into-wet. When this was dry, the buildings and river bank were painted to give definition.*

I did this painting late one winter afternoon in Dartmouth, with the rain steadily beating down on our hotel window. Although the light was going fast, I decided to have a go and paint the scene.

### FIRST STAGE

I started the drawing by establishing the quay on the other side of the River Dart and the mill above it. Once I had drawn in the buildings, the main features of the scene, except for the ferry, were established.

I observed the ferry as it went back and forth two or three times, while shading in the background trees and buildings with pencil. I then decided where I wanted to place it in the painting and, the next time it came across, I drew it in that position. The ferry's wake, caused by the two paddles, was a very important feature.

### FINISHED STAGE

I painted the hill and trees with a watery mix of Crimson Alizarin, Yellow Ochre, French Ultramarine and Hooker's Green No. 1 and worked this wet-into-wet. I used the same colour for the quayside.

I then put a little detail into the buildings. Next I painted the water, leaving the foaming wake as unpainted white paper. Finally, I painted the ferry.

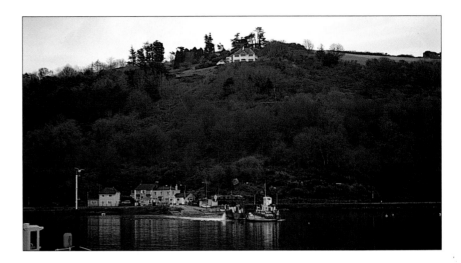

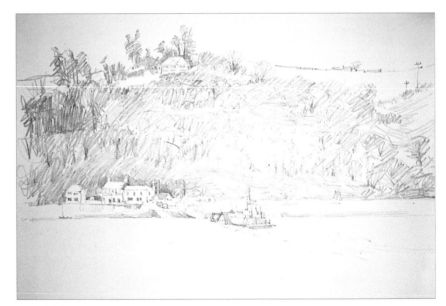

▲ FIRST STAGE

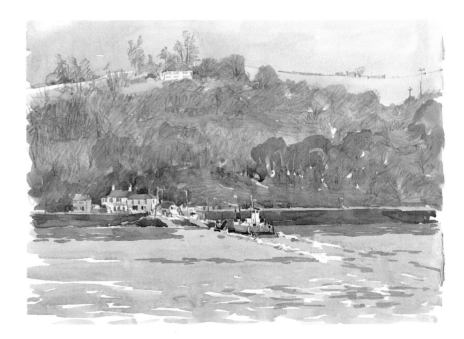

▶ DARTMOUTH FERRY, DEVON
Watercolour on cartridge paper
28 × 40 cm (11 × 16 in)

We have been to Dedham, in Suffolk, which is 'Constable Country', during every season of the year. In fact, we have just returned from another trip, painting for our seventh television series, *Crawshaw Paints Constable Country*. It is a wonderful place to paint.

We are often asked where our favourite location is and our answer is always 'everywhere'! Neither of us has travelled anywhere, in England or abroad, where we haven't felt inspired to paint – even on rainy days!

It was on a day of heavy showers that June painted Dedham Church (above). I was doing a small oil sketch nearby. Every time it started to rain, I closed the lid of my pochade box and my painting was instantly 'waterproofed'.

Working with watercolour isn't so easy and, in the end, this required some teamwork so I held an umbrella over June while she finished her sketch. Some soft sunlight fell on the church tower for a little while and June caught this in her watercolour. There is no detail in the painting but it certainly captures the atmosphere of the day.

▲ RAIN AT DEDHAM
Watercolour on cartridge paper
20 × 28 cm (8 × 11 in)

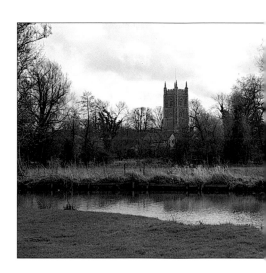

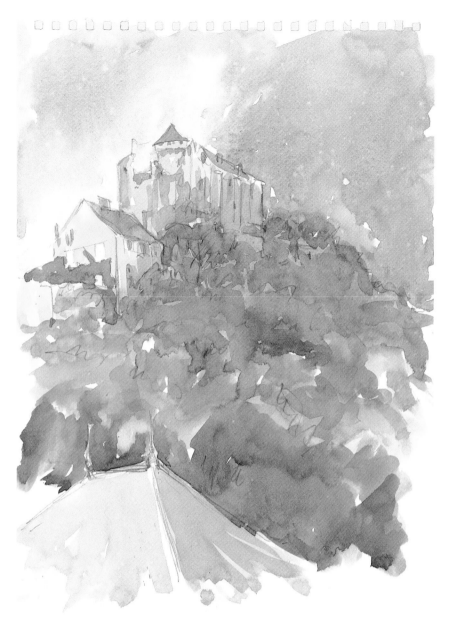

◄ CASTELNAUD IN THE RAIN
Watercolour on cartridge paper
28 × 20 cm (11 × 8 in)

*June painted the castle first and then the cliff and trees, this time working wet-into-wet. When this first stage was dry, she put another darker wash of colour over most of the painting to represent the low clouds and rain. She left a lighter area behind the castle to define its shape (dark-against-light). In the sky there are some light-coloured spots. These were made by the rain blowing onto her painting while she worked.*

On page 13 in the introduction to the book, I told you about the river rising after a night and day of rainstorms while we were teaching in the Dordogne. Naturally, June and I don't stop teaching just because it's raining. Usually we work indoors, giving painting demonstrations, setting up still-life subjects for the class or encouraging students to practise their three-minute sketches. However, on this particular occasion, it was decided, by a unanimous vote, that we would all go out for a day and paint in the rain. The French hotel staff gave us plenty of funny looks as our motley crew of laughing, waterproofed, umbrella-waving English artists climbed aboard a coach in the pouring rain to go on a painting trip!

Eventually, we found a restaurant with an outside eating area. Although all its sides were open to the elements, it had an awning overhead. After some negotiating on the part of the courier, we all settled down to do some painting and eating.

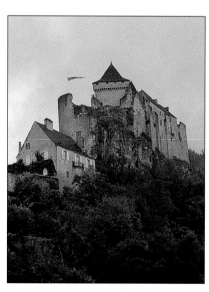

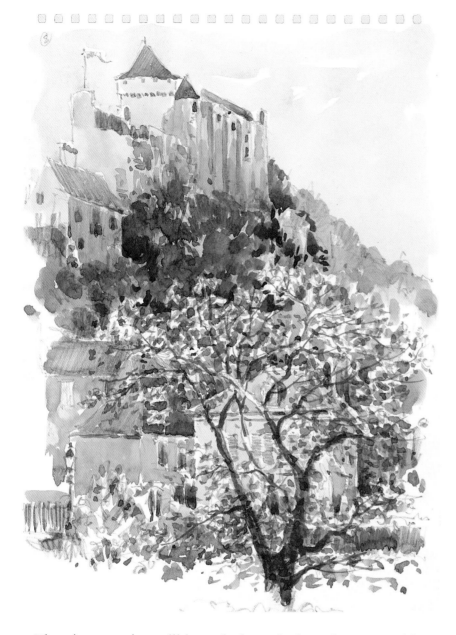

◀ CASTELNAUD IN THE RAIN
Watercolour on cartridge paper
28 × 20 cm (11 × 8 in)

*My painting has rather a strange composition. Your eye is led up to the castle because there is a natural pyramid design. However, there is another strong centre of interest. If you look through the tree at the bottom of the picture, the cream house with the shutter and the dark house next to it makes an interesting area. In fact, you could make two paintings from the top and bottom halves of the picture!*

The view was incredible and, through the rain, we could see the Château de Castelnaud at the top of a wooded cliff. It looked like a fairy-tale castle.

At times while we were painting, the rain clouds completely covered the castle; at other times, they thinned out and allowed more light to filter onto the scene. June did the very dramatic view with low rain clouds, shown on the previous page. I chose a more complicated view (trust me!) with brighter light and this is shown above. It is interesting to compare these two paintings.

The rain cleared later in the afternoon and we all went to Beynac Castle, where I painted the small tree (shown on page 49). If you look closely at that picture, the suggestion of an ochre-coloured building in the distant trees is Castelnaud. We were both delighted with our paintings and were also very pleased with our students' work. Some good paintings were done in the rain that day, and we all thoroughly enjoyed it.

This painting was done between heavy rain showers. Trying to paint, take photographs and write notes while skipping in and out of the rain was quite frustrating but, in spite of this, I really enjoyed doing it and was pleasantly surprised with the result.

Each time it rained, I turned my sketchpad upside-down to protect it and hurried with my chair and open paintbox (travelling studio) to the safety of the shelter I had made behind a boat with my umbrella and some large stones. Weather takes no notice of art – I had to run for cover at least half a dozen times, and always at inconvenient moments in my painting! June, working nearby experienced similar problems.

### FIRST STAGE

I established the quay on the far side of the river and then the main quay.

I then drew in the rest of the picture, shading the dark areas to give them extra emphasis.

I painted the background trees and some of the middle distance next. It is unusual that I painted some of the boats at this stage – if I had been working in the studio I wouldn't have done this. As I have said before, when you are painting from nature, it often dictates the way you work.

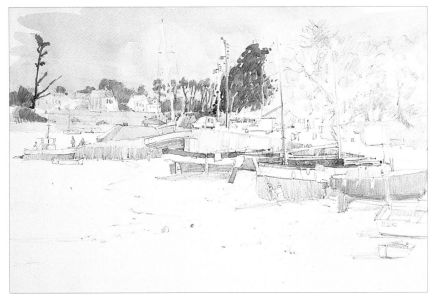

▲ FIRST STAGE

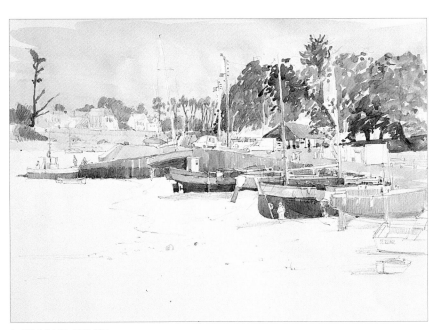

▲ SECOND STAGE

### SECOND STAGE

I then painted the trees, the main quay and put more work into the boats. Apart from the sky, which I painted with my No. 10 sable brush, I had only used my No. 6 sable brush up to this point.

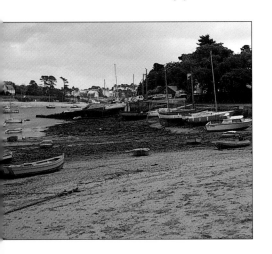

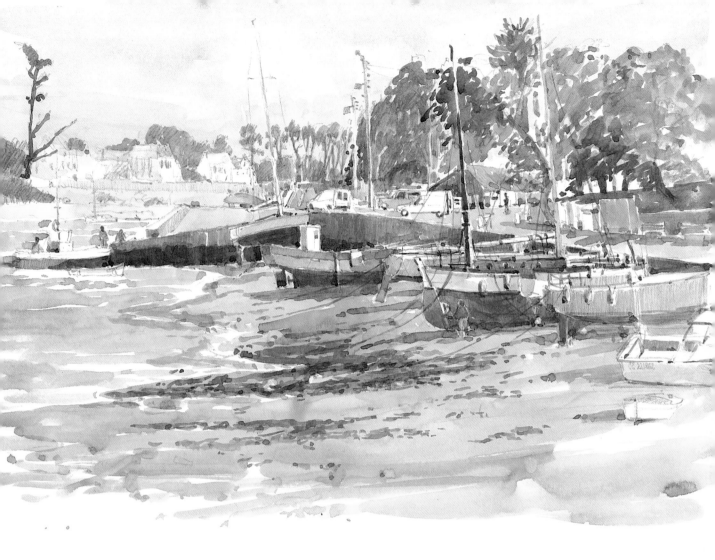

## FINISHED STAGE

Now, using my No. 10 sable brush, I painted in the beach and then the water.

I changed back to my No. 6 sable brush again to add detail to the beach and boats.

Finally, I put in the shadows that were cast by the boats.

▲ FISHING BOATS, BRITTANY
Watercolour on cartridge paper
28 × 40 cm (11 × 16 in)

▼ *It was very important to draw the stern of the boat on the left carefully. The silhouetted shape and the white cabin against the dark background make it easy to recognize and this helps the eye to understand all the other boats, which are crowded together and don't have as much shape or form.*

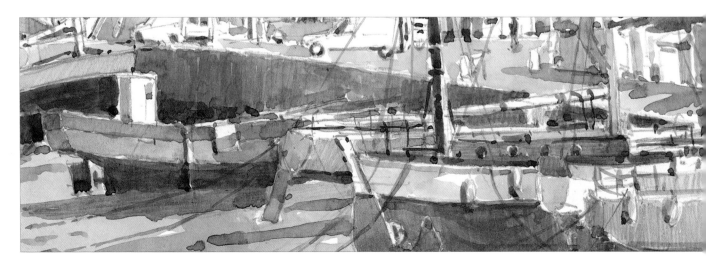

# COMPLICATED SCENES

One of the most important rules when painting a complicated scene is to make sure that the main structural elements are drawn and positioned correctly and that these are in scale with one another before you start to draw in the secondary elements and detail. It doesn't matter how loosely or rapidly a painting is executed, the structure must be in place first, or it will fail.

## DRAW YOUR SUBJECT FIRST

Some very experienced artists can visualize this on their paper or canvas and work from just a few pencil lines. However, I suggest you observe and consider your subject carefully, then draw it in before you start painting. If your initial structure is inaccurate – and you don't realize this until you are halfway through your painting – you will have to start again. Of course, we've all done this. Apart from wasting time, it is also frustrating!

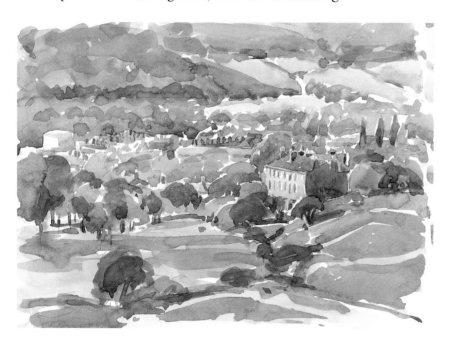

▲ ILKLEY FROM THE MOORS, YORKSHIRE
Watercolour on cartridge paper
20 × 28 cm (8 × 11 in)

*June did this painting very freely and quickly because the light was going. However, she took* *time to observe and position the important elements first, before she painted it. Having to work fast is always a good painting exercise for artists because it sharpens our powers of observation and also stops us fiddling with our work!*

▶ BIRMINGHAM AT NIGHT
Watercolour on cartridge paper
28 × 20 cm (11 × 8 in)

*I painted this scene from my hotel window. After observing it for fifteen minutes, it gradually looked less complicated to me as I became familiar with it. This method always works – try it. I used a 3B pencil for the drawing and you can see this if you look at the texture of the shading on the main building. I used a softer pencil than normal since I had to do a lot of shading and, after looking at the scene, had decided it would make the shading easier.*

This wasn't just a complicated scene – it was constantly changing as well! We had gone to the River Bure in Norfolk, especially to paint the Horning Regatta and were lucky because it was a beautiful day.

We found a little shade under a tree but, when I looked at the scene, I must admit that I had a moment of artistic panic! Yachts were dashing everywhere, manoeuvring and missing each other by inches – all you could see were the white sails and their reflections in the disturbed water. The thought went through my head, 'You don't need to paint this!' It was certainly a challenge. Incidentally, June felt exactly the same way as I did.

I sat for about five minutes familiarizing myself with the scene, then started to draw it.

### FIRST STAGE

Using my 2B pencil, I drew in the line of the opposite bank. I waited for a yacht to cross in front of me, drew it in and felt that I had achieved something. Then I saw another coming directly towards me so I drew that one in, too, and then put in the two brown ones on the left of the red buoy and the sails in the background. I then did some shading with my pencil.

▲ FIRST STAGE

▼ SECOND STAGE

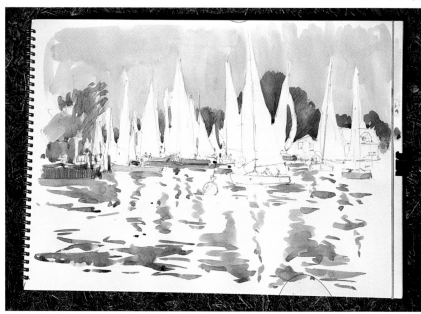

### SECOND STAGE

I used my No. 10 sable brush for the sky. Because it was a very hot day, the sky in the top left of the painting dried out very quickly – hence the 'run backs'.

When I painted the trees it was important to leave unpainted white paper to show the shapes of the white sails.

I painted the varnished wooden yachts next. At this stage, all the nervous energy I had used could have been wasted. I had to paint the water. If this went wrong, the painting would be ruined. I studied the water, decided how I would paint it, held my breath and did it. I wanted to show the movement and reflection of the sails. I was pleased – it worked. At that point, there was a loud hooter sound and the yachts sailed up the river. In a matter of minutes, they were gone.

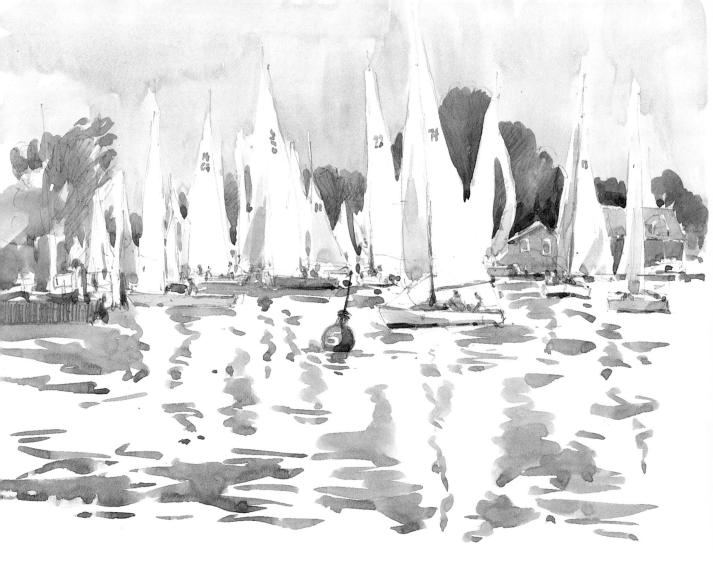

## FINISHED STAGE

Fortunately, by now I had seen enough to continue adding the final details to the painting. June finished at the same time, so we both had a well-earned cup of tea! Incidentally, if you wanted to do a full-blooded painting of a subject such as this, you would have to do a painting like we did, take photographs for reference and then work at home where you would have time to reflect and add detail.

▲ HORNING REGATTA
Watercolour on cartridge paper
28 × 40 cm (11 × 16 in)

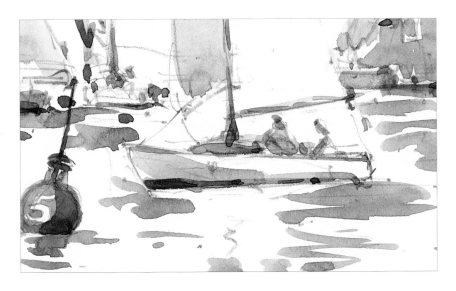

◄ *As with the boats on the beach on page 116, I made sure that I drew at least one yacht reasonably well. You will notice that I didn't put in any reflections of the crew in the water. If I had been in the studio, I would have put these in. However, I was working from nature – in real life, I couldn't see them. In fact, I've only just realized that they're missing!*

June was sitting under the tree with me when I did the painting on the previous page. However, she decided to paint a different scene to mine, looking to the right, where the yacht club was situated.

### FIRST STAGE

June's drawing had to be fairly sketchy, as the yacht club kept disappearing from view behind the sails and the spectators on the bank. Since she wasn't sure exactly what was there, she decided to paint an impression of what she saw, without any detail. This is one way of painting a complicated scene.

Because her drawing didn't have much structure, June was able to watch the images, shapes and colours moving on the river and she painted what she saw, without being restricted to absolute form or detail.

She started painting the sky and the background trees first.

### SECOND STAGE

The red and yellow bunting was painted next and then the water. Everything was worked very loosely – notice how June's free brush strokes left unpainted white paper to represent yachts and sails on the left-hand side of the painting.

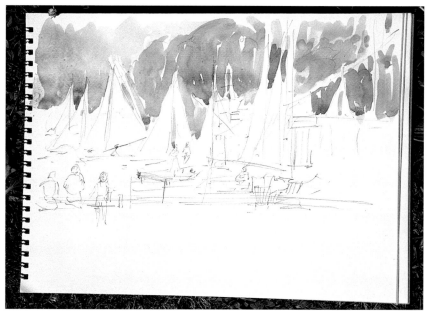

▲ FIRST STAGE

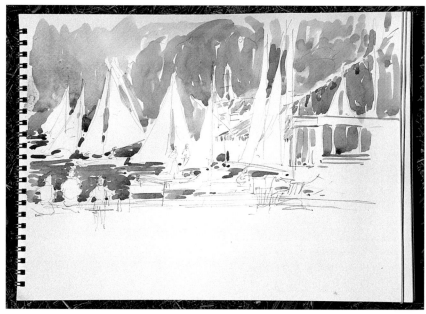

▲ SECOND STAGE

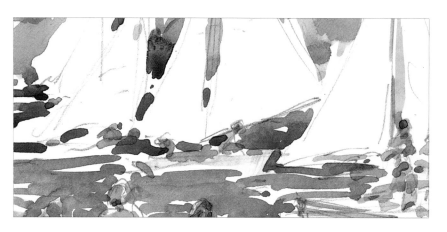

◀ *When she painted, June followed the general shapes that she had drawn with pencil. But her brush strokes made the final marks and shapes. Don't try to follow your pencil lines too carefully or your painting won't flow naturally.*

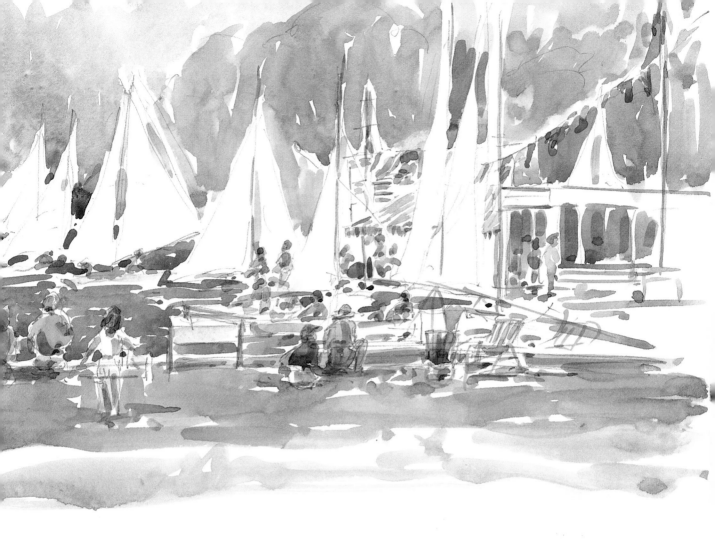

## FINISHED STAGE

This stage was the most exciting. With her No. 6 brush, June suggested the spectators with 'blobs' of paint, then added darks and more bright colours where she felt it helped her painting. It worked and she captured the atmosphere of this complicated subject very successfully.

▲ YACHT CLUB, HORNING
Watercolour on cartridge paper
20 × 28 cm (8 × 11 in)

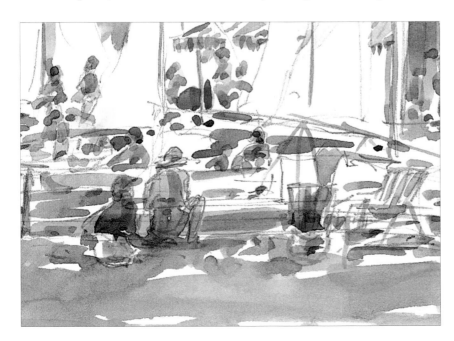

◀ If you look carefully, this area is just suggested, although June drew the two figures at the front more carefully. This helps to establish the ones behind them.

June had chosen an equally difficult scene when she did the painting (below). Traffic kept passing or parking at the top of the quay. As she finished drawing, the red van on the left moved off and a larger one parked and blocked out most of her view! This is something you must be prepared for and accept in a busy location.

The scene for my painting (right) was completely the opposite to this – no people, no traffic, and no water, so even the boats couldn't move away! The weather was warm and sultry and the scene was complicated so I knew I was going to enjoy it. It took me over an hour and, before I had finished, the tide had come up and covered all the mud!

There's always something to contend with working outdoors but it does make working exciting and memorable. June and I love it. Good luck on *your* painting travels!

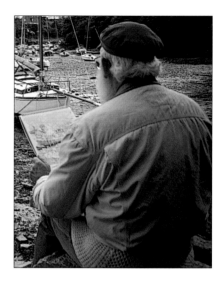

◀ JERSEY
Watercolour on cartridge paper
28 × 20 cm (11 × 8 in)

*The background buildings were painted very freely because June had to keep peering around a big parked van to see them. However, she painted the building in the foreground on the left carefully because it played a prominent part in the painting.*

▶ HARBOUR, DOELAN, BRITTANY, FRANCE
Watercolour on cartridge paper
40 × 28 cm (16 × 11 in)

*I did plenty of drawing and shading with my 2B pencil for this picture. Because so much of the tonal work was achieved with pencil shading, the painting was simple and didn't take long to do. Notice that I didn't paint over the distant trees but just left the pencil showing there.*

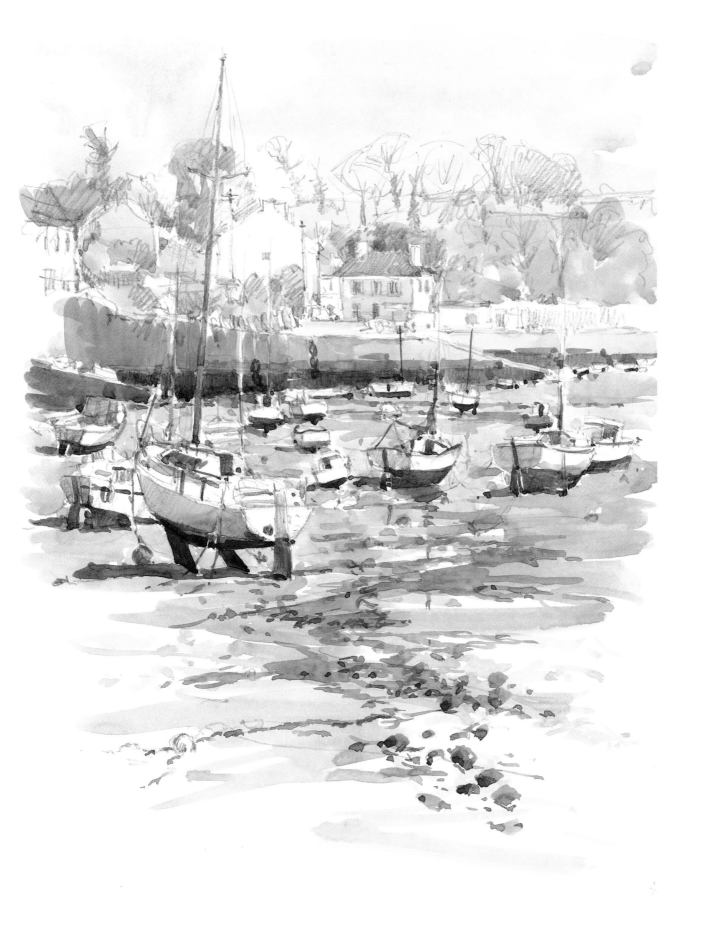

## FROM ALWYN'S SKETCHBOOKS

While compiling this book and looking through the sketchbooks I have filled over the past few years, it amazes me just how much I am drawn to water and boats. I do like painting them, but I enjoy sketching them just as much. In fact, it gives me a tremendous thrill, even if nothing more is done with the sketch afterwards.

When I was at art school in Hastings, the fishing fleet was flourishing and I used to enjoy going down to the beach and sketching the boats. Back then, I found them very difficult to draw because they were all clinker-built, with hulls constructed with each plank overlapping the one below. I could never get those planks to look correct. But you don't see many of those about now, luckily!

Whatever you draw – no matter how small or insignificant – every sketch will bring back memories. While a photograph only captures a split second of activity, a sketch can be far more evocative.

When you sketch, you have to really observe and consider the things around you. You will find you become sensitive to your surroundings as you spend time doing a sketch or painting and this same feeling will come flooding back when you look at your sketches years later. So, my advice is, whatever you take on your travels – remember always to take your sketchbook and pencil with you.

Happy sketching!

TURBOT